VISIONARY WOMEN

✦

EMMA LAZARUS

VISIONARY WOMEN

Also in this series:

THE TRAVELS OF EGERIA
Karen Armstrong

CHRISTINA OF MARKYATE
Monica Furlong

FLORENCE NIGHTINGALE: LETTERS AND REFLECTIONS
Rosemary Hartill

THE MARTYRDOM OF PERPETUA
Sara Maitland

THE TRIAL OF JOAN OF ARC
Marina Warner

Other titles in preparation

VISIONARY WOMEN

Series editor: Monica Furlong

EMMA LAZARUS

POET OF THE JEWISH PEOPLE

A selection of Poetry and Prose

with an introduction and commentary by

EMMA KLEIN

ARTHUR JAMES

BERKHAMSTED

First published in Great Britain in 1997 by

ARTHUR JAMES LTD
70 Cross Oak Road
Berkhamsted
Hertfordshire HP4 3HZ

A catalogue record for this book is available
from the British Library.

ISBN 0 85305 369 3

Typeset in Monotype Sabon by
Strathmore Publishing Services, London N7

Printed and bound in Great Britain by
Guernsey Press Ltd, Guernsey, C.I.

This book is dedicated to the memory of

Rabbi Hugo Gryn (1930–1996)

another who bore the light of his people to the
nations and left this world too soon .

THE CHOICE

I saw in dream the spirits unbegot,
Veiled, floating phantoms, lost in twilight space;
For one the hour had struck, he paused; the place
Rang with an awful Voice:
 'Soul, choose thy lot!
Two paths are offered; that, in velvet-flower,
Slopes easily to every earthly prize.
Follow the multitude and bind thine eyes,
Thou and thy sons' sons shall have peace with power.
This narrow track skirts the abysmal verge,
Here shalt thou stumble, totter, weep and bleed,
All men shall hate and hound thee and thy seed,
Thy portion be the wound, the stripe, the scourge.
But in thy hand I place my lamp for light,
Thy blood shall be the witness of my Law,
Choose now for all the ages!'
 Then I saw
The unveiled spirit, grown divinely bright,
Choose the grim path. He turned, I knew full well
The pale, great martyr-forehead shadowy-curled,
The glowing eyes that had renounced the world,
Disgraced, despised, immortal Israel.

Contents

Series Foreword 13

Acknowledgements 17

Introduction 19

Echoes 39

From *Epochs* 40

PART ONE: Her People's History

from *The Last National Revolt of the Jews* 43

Bar Kochba 45

from *The Last National Revolt of the Jews* 46

from *The Jewish Problem* 51

Longing for Jerusalem 52

By the Waters of Babylon: Treasures 53

The World's Justice 54

from *The Jewish Problem* 56

Gifts 57

By the Waters of Babylon: The Sower 59

from *Raschi in Prague* 61

from *The Jewish Problem* 64

from *The Guardian of the Red Disk* 65

Two extracts from *The Dance to Death* 66

from *The Jewish Problem* 79

from *An Epistle to the Hebrews X* 80

from *An Epistle* 81

1492 85

By the Waters of Babylon: The Exodus 86

In the Jewish Synagogue at Newport 86

The Supreme Sacrifice 90

By the Waters of Babylon: The Test 91

The Crowing of the Red Cock 92

Venus of the Louvre 94

from *The Poet Heine* 95

from *To Carmen Sylva* 100

from *Russian Christianity versus Modern Judaism* 101

from *The Jewish Problem* 102

from *An Epistle to the Hebrews XIII* 103

from *An Epistle to the Hebrews XI* 104

By the Waters of Babylon: Currents 105

In Exile 106

Contents

from *An Epistle to the Hebrews XIII* 108

The New Colossus 109

from *The Jewish Problem* 110

from *An Epistle to the Hebrews V* 111

from *An Epistle to the Hebrews XII* 112

PART TWO: Her Vision

The Valley of Baca 117

By the Waters of Babylon: The Prophet 119

By the Waters of Babylon: Chrysalis 121

The New Ezekiel 122

from *The Jewish Problem* 123

from *The Jewish Problem* 124

The Banner of the Jew 125

from *An Epistle to the Hebrews XV* 127

The New Year 130

from *An Epistle to the Hebrews VIII* 132

The Feast of Lights 135

from *An Epistle to the Hebrews: Introductory* 137

from *An Epistle to the Hebrews II* 139

from *An Epistle to the Hebrews VI* 141

Contents

from *An Epistle to the Hebrews VII* 143

from *An Epistle to the Hebrews XI* 145

from *Judaism the Connecting Link
between Science and Religion* 147

from *An Epistle to the Hebrews X* 148

from *M. Renan and the Jews* 150

from *The Jewish Problem* 151

PART THREE: Patriot of Freedom

from *On the Proposal to Erect a Monument
in England to Lord Byron* 155

from *How Long?* 157

from *Sic Semper Liberatoribus* 158

Sunrise 160

from *A Day in Surrey with William Morris* 164

Letter to Henry George 166

Progress and Poverty 168

Notes 169

Bibliography 175

Series Foreword

Women, in our view, have always had interesting and valuable things to say about religious meaning, and about the life of the spirit, often with a different emphasis and accent from men writing and speaking about the same thing. It is not, probably, that women are so very unlike men. It is more that, historically, their life experience has been so different that, as you might expect, they saw events and ideas through a very different glass.

In the case of Christianity it is very difficult to know what they *did* see and feel. For the first eleven centuries of the Christian church they were almost completely silent, so far as writing and public speaking were concerned, forced to be so partly by lack of education, partly by those deadly chapters in the Epistles that commanded women to be 'silent in the churches', a prohibition that extended beyond the church in a framework that set up rigid conventions, confining women within home or convent. Very, very occasionally a woman's voice breaks through – as Perpetua tells us of the horror of her imprisonment before her martyrdom (third century), or the nun Egeria tells us of her travels (fourth century). It was only from the twelfth century onwards that voices of Christian women began, very tentatively, to emerge, or at least this was the time when women's writings began to be preserved so that they have come down to us.

Nor were other religions so very different. In widely

different cultures and religions – Judaism, Buddhism, Hinduism, Islam – it was assumed, as it was in Christianity, that caring for their husbands and bearing children somehow removed women from making any other sense of their lives or of the world about them. Of course women tried to do it – how can any human being not? – but their views were not sought or recorded.

As a Christian I cannot speak for other religions (though I hope others will speak for some of them in the course of the series), but I observe that everywhere women seem less and less willing to be silent and passive participants. Within Christianity now, there is a healthy and growing remorse for all that was lost when women's voices were silenced.

This series of books attempts to salvage some of the texts (often very little known even by feminists) which remind us what it sounded like when women first began to make their voices heard, and what they said as they described the experiences which shaped their thinking. It also uses material by later women who, one way or another, broke new ground in their actions, their ideas and their self-expression. Some of these are well known, but have often been presented to us in oddly distorted ways, which suggests that it is time for some reassessments.

It is not our intention to use these texts wholly uncritically – that would be to patronize the writers – but rather to use them to develop our own thinking. The early material, in particular, often needs effort, as it invites us to make use of ideas, and a view of religion, extraordinarily different from our own.

Our hope is that readers will want to make a small

collection or library of these precious texts – a reparation to the forgotten women, but also, we believe, a fruitful source of inspiration and ideas for ourselves, the fortunate heirs of their courage and determination.

MONICA FURLONG

Acknowledgements

I would like to thank Monica Furlong for asking me to contribute to the 'Visionary Woman' series and for helping me decide on Emma Lazarus.

Thanks are also due to the librarian at the Jewish Studies library at University College, London, for her cooperation and to the librarians at Jews College, London, for their patience in providing access to *The American Hebrew*. Poring over these crumbling volumes enabled me to imbibe the atmosphere of Emma Lazarus' times.

I am grateful to Gordon Pocock, as ever, for his interest and encouragement. I am particularly indebted to Professor Morris Schappes who kindly sent me the latest reprint of his very interesting selection of Emma Lazarus' poems and prose and who took the time to have his one copy of *An Epistle to the Hebrews* copied for me.

Most of all I must thank my husband, Chaim, for his constant patience and support, and for his invaluable help in getting the text together.

Introduction

I

I first came across Emma Lazarus, the American Jewish poetess, in a slim volume of biographies of ten significant Jewish figures from King David to Chaim Weizman. [1] One of three women [2], she was clearly, for me, the most appealing. It appeared, too, that at a time when the bulk of world Jewry was concentrated in eastern Europe, she had foreseen that the future centres of Jewish life would be in the United States and Palestine; a pretty impressive prediction, particularly as she died in 1887 when the new immigrations of Jews fleeing pogroms was beginning, a decade before the official Zionist movement took off.

The 'bio' had cited a few lines from Lazarus' principal claim to immortality – her sonnet, *The New Colossus*, inscribed on the Statue of Liberty:

> Give me your tired, your poor,
> Your huddled masses yearning to breathe free,
> The wretched refuse of your teeming shore.
> Send these, the homeless, tempest-tost to me.
> I lift my lamp beside the golden door.

Stirring words. Nevertheless, the text I would have

Numbers in square brackets, e.g. [4], refer to the Notes which begin on p. 169.

to reproduce remained very much an unknown quantity. It was no coincidence, however, that shortly after discovering Emma Lazarus, I happened to find an essay on her in a Jewish literary periodical which gave me the courage to persevere. [3]

Here was my 'visionary woman' but I knew very little about her. Phone calls to several libraries, American and Jewish, drew a blank: nothing on or by Emma Lazarus. Eventually I discovered that the Jewish Studies library at University College, London, had three volumes of her poetry printed in the 1880s and one selection of poetry and prose published during the 1940s; this latter was to prove invaluable.

My eyes scanned the introduction by the Lazarus scholar Morris U. Schappes and focussed on some of the first poems in the selection: *The Choice*, *The Banner of the Jew*, *Gifts*, *Venus of the Louvre*, each offering in its different way a profound insight into the Jewish condition. I was filled with elation; I had discovered a soul-sister. It was surely not mere chance that we had the same name and that our birthdays fell within two days of each other. The fact that I had come into this world almost a hundred years after her seemed of little consequence.

I was fortunate that my first solid introduction to Emma Lazarus came from Professor Schappes. As I was to discover in the months I devoted to her work and her vision, her short life and its achievements – she died of cancer aged 38 – have been subject to varied interpretation. It is Schappes' perspective, albeit far more expert, that most closely resembles my own.

II

A few facts about her life and writings remain beyond dispute. Emma Lazarus was born in New York City on 22 July 1849, the fourth of six daughters and one son born to Moses Lazarus, a well-to-do sugar-refiner of Sephardic ancestry, and his wife, Esther Nathan Lazarus, of Ashkenazi background. Emma and her sisters were privately educated at home and she is likely also to have attended a private school. She was clearly well-versed in languages as her first collection of *Poems and Translations*, published by her father in 1866 for private circulation, included translations from Hugo, Dumas, Schiller and Heine. Her second volume of poetry, *Admetus and Other Poems*, published commercially in 1871 and reprinted in 1970, received plaudits from journals in Britain and America and was followed in 1874 by the publication of *Alide*, a prose romance on an episode of Goethe's life. Lazarus continued to publish poems, translations – also from Italian – and essays in a variety of periodicals and wrote a five-act verse tragedy, *The Spagnoletto*, which she published privately in 1876. In 1881 her *Poems and Ballads of Heinrich Heine* appeared to critical acclaim.

The following year witnessed the publication of her first overtly Jewish collection of work, *Songs of a Semite: The Dance to Death and Other Poems*. This included a five-act verse tragedy, *The Dance to Death*, dedicated to George Eliot, and a selection of translations of the Hebrew poets of medieval Spain which she had adapted from a German version. She later took lessons in Hebrew to be able to translate from the original. *Songs of a Semite*

was favourably reviewed by a variety of American and British critics. At that period and in the months that followed Lazarus published a number of essays and poems on Jewish themes in both general and Jewish periodicals, notably the fifteen-episode *An Epistle to the Hebrews* in *The American Hebrew*.

After her death, a posthumous collection of her verse and translations, compiled by her sisters Mary and Annie, was published in two volumes with a biographical introduction by her sister, Josephine. *An Epistle to the Hebrews* was reprinted in book form in 1900 by the Federation of American Zionists and again by the Jewish Historical Society of New York in 1987, edited by Morris U. Schappes. In 1903 *The New Colossus*, written twenty years earlier, was inscribed in the pedestal of the Statue of Liberty. In 1944 Morris U. Schappes published *Emma Lazarus, Selections from her Poetry and Prose*. This has been reprinted five times, most recently in 1982.

III

So much for hard facts. What is more to the point is that Emma Lazarus has become something of an American-Jewish hero even if most of her work is out of print and inaccessible. The last three reprints of the Schappes selection, for example, have been sponsored by the Emma Lazarus Federation of Jewish Women's Clubs.

Hero-status is liable to beget myths and myths, in turn, beget debunkers. Both the personality and lifestyle of Emma Lazarus have been the subject of fable and deconstruction, as has her relationship to her Jewishness.

Myth number one centres on Emma's supposed relationship with her father. The Lazarus family was close-

knit and it would appear that Emma's precocious talents were the focus of her father's attention. Certainly the fact that he published her early poems is testimony of his paternal pride and encouragement. The Lazarus sisters seem to have been exceedingly dutiful daughters, remaining with their father after he was widowed until his death in 1885. Significantly, none of them married before he died. In her essay, Josephine writes of the effect of his death: 'The blow was a crushing one for Emma. Truly, the silver cord was loosed and the golden bowl was broken. Life lost its meaning and charm. Her father's sympathy and pride in her work had been her chief incentive and ambition, had spurred her on when her own confidence and spirit failed.' [4]

In light of the scope of Emma Lazarus' later work, it seems incongruous to limit her motivation to the desire to impress her father, even if this had been a prime objective of her early literary efforts. While Josephine does refer to the fact that Emma was stricken by a serious illness in the summer of 1884, she does not appear to recognise this as the first stage of the cancer that killed her, nor take account of its effect on Emma's well-being. To conclude, then, as some who wrote on her later have done, that Emma was fixated on her father to the exclusion of other men, seems far-fetched.

Significantly, Emma sent her first collection of poems to Ralph Waldo Emerson, the eminent writer, who recognised her ability and became her mentor. The fact that she sought recognition beyond her immediate circle belies myth number two, the image of a reclusive, melancholic, shrinking young woman, also conveyed in Josephine's essay, which many 'Lazarites' have taken as gospel. Shy

and sensitive she may well have been, but her correspondence and personal contact with Emerson paved the way for a number of literary relationships with eminent writers, poets and thinkers in two continents, including Henry James, Robert Browning and William Morris. She was also in correspondence with Ivan Turgenev to whom she sent a copy of *Alide*.

Emma also enjoyed a number of close friendships and social relationships, as might be expected in the case of an intelligent, gifted, pleasant-looking, well-to-do young woman. A recently published volume of previously unknown letters reveals a wealth of detail regarding her social and cultural pursuits and sheds light on her activities during her two trips to Europe, when she was received by a virtual *Who's Who* of cultural and Jewish personalities. [5]

While Emma never married, the 'spinster stereotype' that has attached to her in 'Lazarite' circles would also appear to be misleading. The possibility of an unrequited attachment to one of her cousins has been touched on by some commentators and dismissed by others. The dearth of Jewish candidates of similar background and status is unlikely to have proved the main obstacle to matrimony as her father was proud to be a member of various exclusive gentile clubs and, more pertinently, her brother was married to a non-Jew. Recent research has revealed that she may have experienced a more than platonic relationship with the brother of one her closest friends who is likely to have found her Jewishness a barrier to a serious connection. [6] In any case, since she was already mortally ill by the time her father died, even if she was unaware of this, time was running out for her.

IV

Emma Lazarus' relationship to her Jewishness has be-
devilled the majority of commentators, the debunkers as
much as the fabricators of myths. The fact that most of
her friends were Christian and that one posthumous eulo-
giser described her as being 'as much a Christian as a
Jewess' [7] has encouraged some more recent commenta-
tors to put forward tortuous constructs of their own.

It would be well to start with Emma's own family
background. Both the Lazarus and Nathan families had
roots in America from the time of the revolution, a key to
their being accepted in gentile society. The Moses
Lazaruses belonged to a prominent Sephardic synagogue,
where earlier ancestors on both sides had been active, but
were not themselves observant. Emma and her family
would, consequently, fall into the category of old-time,
acceptable 'Hebrews' as opposed to *parvenu*, unaccept-
able 'Jews', 'Israelites' or 'Sheeneys', a distinction that
was to prove crucial as America fell prone to a wave of
social antisemitism from the late 1870s onward.

The focus of this hostility were the German Jews who
had immigrated to America from the 1830s and prospered
greatly in the new country. One man who encapsulated
the rags to riches syndrome and became the first visible
butt of prejudice was Joseph Seligman, a peddler who
became an exceedingly prosperous merchant and banker,
admired by two American presidents. In 1877, however,
he was turned away from the luxurious Grand Union
Hotel, where he had regularly held a suite, on the instruc-
tions of the new owner, Judge Henry Hilton. The episode
sparked a *cause célèbre*, but despite support for Seligman

from the press and prominent Protestant clerical and lay personnages, the trend continued and most top hotels and social clubs in America were closed to 'Seligman Jews'. [8]

Where does all this leave Emma Lazarus? Her sister, Josephine, suggests that the 'somber streak' in the young poet's personality reflected 'the stamp and heritage of a race born to suffer', although 'Hebraism was only latent so far'. So insistent is Josephine on the dormant nature of Emma's Jewish consciousness, even in 1881 after the publication of her volume of Heine translations, that she claims that Emma was 'as yet unaware or only vaguely conscious of the real bond' between her and Heine, 'the deep, tragic, Judaic passion of eighteen hundred years that was smouldering in her own heart ...' What Josephine posits is a virtual 'Damascus Road conversion' on her sister's part, sparked on the grander scale by the brutality of the pogroms in Russia and the influx into America of Jewish refugees, and in particular by an anti-semitic article justifying the pogroms that appeared in *The Century* magazine in April 1882, to which Emma was invited to respond. Josephine goes so far as to suggest that until then Emma had as little enthusiasm 'for her own people' as for 'obsolete' Judaic rites; curiously, she cites in justification Emma's essay on Disraeli: *Was the Earl of Beaconsfield a Representative Jew?* which appeared, as if by coincidence, in the same April 1882 edition of *The Century*. [9]

Here, then, are the foundations of the 'myth' relating to Emma Lazarus' Jewishness, which many later commentators have adhered to. This interpretation has been vigorously challenged by Professor Schappes, who points to landmarks in Lazarus' work which indicate a Jewish

sensibility as early as 1867, when she wrote *In the Jewish Synagogue at Newport*. Other manifestations include her translation of the Hebrew poets of medieval Spain (1879) and her version of Heine's *Donna Clara* and the two 'imitations', based on Heine's own notes, with which she continued the underlying theme of Christian antisemitism (1876). Most significant is her tragedy, *The Dance to Death*, a *tour de force* on the same subject; this was put forward for publication in 1882, when she considered the time was right but, as she made clear to her publisher, written a few years earlier.

Certainly most of Lazarus' Jewish writings and her active involvement on behalf of her fellow Jews was concentrated in a relatively short span of some two years. This can be explained as a response to a crisis or, to use her words, a 'storm centre' in the history of her people. Where, as Professor Schappes has suggested, she had shown an interest in 'Jewry distant and past', she was now confronted with a situation that was present and near at hand. She herself acknowledged that she flung herself headlong into this commitment and became consumed by it, to the virtual exclusion of all else. [10]

It is true that in the midst of this period she travelled to Europe to gain support for her plan for the resettlement of persecuted Jews in Palestine and spent over four months there, delighting in a new cultural and social scene into which she was welcomed as something of a celebrity. She returned to Europe after her father's death, 'feeling about twenty years older than when I was here last, trying with all my might and main to get back a healthy, natural way of looking at this beautiful world of ours'. [11] She remained there over two years but for the

last third of her stay was bedridden and too ill to travel. She was brought home in July 1887 and died on 19 November that year. Some recent commentators have focussed on her travels and her many interests outside the Jewish world to imply that her dedication to the Jewish cause was in some way 'a flash in the pan'. Such an interpretation is unjustifiable, as is the insinuation that Lazarus may have felt comfortable in 'raising the banner of the Jew' at a time when the Jewish question was of interest in well-bred gentile circles.

V

Emma Lazarus' strong, yet undeniably complex Jewish identity, an integral quality of her vision, cannot be adequately explored outside the context of her work. While she readily acknowledged that she was a 'real unconverted Jew', to use the words of Emerson's daughter, Ellen, whom she met in 1876, this had little bearing at that stage on her literary efforts. Under Emerson's influence she read widely and composed a number of poems on classical themes in the somewhat ornate mode of the time. Several are imbued with her mentor's transcendentalist perspective and contain sparks of spirituality, even the occasional turn of phrase that is unconsciously visionary. But by the end of the 1870s she confided in the literary critic Edmund Clarence Stedman, who had become another mentor, that she had 'accomplished nothing to stir, nothing to awaken, teach or to suggest' in her poetry. He suggested that rather than pursue art for art's sake, she should take inspiration from her Jewish heritage.

It is significant that once Jewish themes started to dominate her work, she infused her commentaries on the

current situation with constant references to Jewish history and recreated the Jewish past in terms that evoked the present – and future. Her concern was with the Jewish masses of eastern Europe who had been persecuted and remained vulnerable to persecution, with the refugees who were streaming into her native America, with the 'Seligman Jews' who were stigmatised because of their race. Her response was twofold. She personally assisted in the absorption of the immigrants, visiting them in their refuges on Ward Island, and proposed schemes to train them in new skills; she helped in the Hebrew Immigrant Aid Society and the Hebrew Technical Institute was set up at her instigation. At the same time she appealed passionately for a national home for the Jewish masses in the land of their ancestors. Her call was in tune with the vision of early gentile Zionists like the late George Eliot, [12] whom she revered, and the traveller Laurence Oliphant; it also stemmed directly from her belief that the Jewish problem was rooted in the exile of nearly two millennia.

To see Emma Lazarus as a visionary of Jewish redemption is to confront a central paradox. Here we have a refined, well-born young woman with a foothold in the gentile world and little in common with the *Ostjuden* [13] of the ghettoes whom she embraces as her people. To expect her to feel a personal kinship with the refugees she was trying to help would be unrealistic; commentators who insist that 'she needed to maintain the separateness of Jews like herself from them' [14] are being unnecessarily pedantic. Similarly the claim that Lazarus' work has not held up because 'it has the feel of outsideness ...' [15] is not convincing. On the one hand, to be an outsider,

neither completely at home in the gentile world nor among fellow Jews, is quintessentially Jewish; secondly, the outsider, sparked by passion, has the capacity for vision that an insider might lack. Theodore Herzl, after all, was an assimilated Jew until he witnessed the Dreyfus affair.

The fact that Lazarus' vision is no longer fashionable today has led to a host of charges against her. She has been criticised for the 'strident' [16] tone of her Jewish polemic, particularly *An Epistle to the Hebrews*. This may appear 'archaic' [17] in language and content but many of her observations were to prove strikingly relevant during the century after her death and some remain pertinent today. Rather than 'strident', I would be inclined to use the word 'passionate'. She has also been accused of being 'racist'. [18] This may refer to her Jewish chauvinism – a belief, *à la* Disraeli, in the intrinsically heroic qualities of the Jewish people – or, more probably, to her less than flattering descriptions of the eastern Jews. Her rhetoric, on occasion, is not dissimilar to that of antisemitic stereotype – hence the reproach that it is 'offensive to a post-Holocaust generation'. [19] However, she is painstaking in pointing out the virtues and values that persisted beneath the less than beautiful exterior of the ghetto and its inhabitants. At times her use of language is almost endearingly inconsistent; in one part of an essay she calls for 'a sweeping out of the accumulated cobwebs and rubbish of Kabala and Talmud' and refers later to this presumed obscurantism as the 'time-honored customs and most sacred beliefs' of the 'vast majority of East European Israelites'. [20]

Her use of social Darwinism has earned her censure,

yet there is surely some truth in her contention that if the Jew was flawed, a history of Christian persecution had made him so and, conversely, that if the Jew was placed in an environment of freedom, he would prosper. Her call for the Jewish refugees to be trained in manual and agricultural skills has been derided; [21] while such pursuits may have been the exception among the Jewish immigrants in America, they were very much the rule in Palestine and undoubtedly contributed to the physical robustness of the early Jewish settlers.

She has also been taken to task for limiting her 'Zionist' vision of resettlement in Palestine to the Jewish masses no other country wanted and, at the same time, failing to appreciate America's capacity to absorb millions rather than thousands of Jewish refugees. What her critics are implying is that she, like other established American Jews, feared that a flood of alien Jews would only jeopardise their own situation. It is true that she did not proclaim the ingathering of all the exiles in a Jewish national homeland and was careful to emphasise that support for the concept of such a homeland was no slur on the patriotism of American Jews. All she was asking for was solidarity and support for their less fortunate brethren.

With the benefit of hindsight, the accuracy of her vision is astounding. Was there not a desperate need for a politically independent homeland when the doors of the civilised world, including America, were closed to the Jewish masses trapped in Europe during the 1930s and 1940s? And in a post-Zionist era, the validity of the diaspora as a counterpart to the Jewish state is acknowledged by all but the most diehard Zionists.

VI

It is clear, to me, that many of the criticisms designed to topple Lazarus from her hero's pedestal reflect the bias of the testimony of Emma's favourite younger sister, Annie.

Annie married a Protestant in 1891 and later converted to Anglicanism. She distanced herself from her Jewish connections and broke off relations with her sister, Josephine, when the latter wrote a pamphlet in defence of Alfred Dreyfus. As Emma's literary executor, Annie denied a publisher [22] the right to reprint Emma's Jewish poems in 1926. She dismissed these works as 'sectarian propaganda', a 'phase in my sister's development, called forth by righteous indignation at the tragic happenings of those days' and 'unfortunately, owing to her untimely death ... destined to be her final word.' [23]

Might there not be some link between Emma's 'untimely death' and the fact that her Jewish vision was to be 'her final word'? According to Jewish mysticism, a soul is sent to this world to accomplish a particular task and once this is done, it may be released to a 'better place'. While I am hardly enamoured of such a viewpoint, I feel, in the case of Emma Lazarus, that it has some basis in reality. In the words of one of her well-born friends, Emma's 'eager spirit seemed to burn like an unfailing lamp'. [24] A recent commentator, recounting her personal contact with the refugees on Ward Island, called her 'a soul on fire'. [25] And in one of the rare instances when she shared her preoccupation with Jewish concerns with a gentile friend she wrote: 'I am doing all I can to try to keep myself from being utterly absorbed in a single thought & a single work. As you say, it may, & probably

will, fill my life. There is so much to be done & my strength is so little ...' [26]

It is significant that far from receiving enthusiastic backing from her American Jewish readers, her call for a new Jewish nationalism was rejected in many quarters. Similarly, the Society for the Improvement and Colonisation of East European Jews that she set up with a few talented young men [27] was short-lived. Little wonder, then, if she felt despondent.

If this young woman, whose voice resounded with a maturity well beyond her years, sought relief in the time that remained to her in friendships and pleasures outside the Jewish sphere, who could blame her? For Emma Lazarus had been consumed by the task she was destined to fulfil.

VII

In endeavouring to compile an anthology of poems and prose extracts that convey Emma Lazarus' visionary qualities, I risk offending Lazarite purists. My selection has, in the main, been assembled to describe a history. Rather than keeping extracts from the essays – for example *The Jewish Problem* or *An Epistle to the Hebrews* – in unified blocks, I have divided them into segments of text to be placed where I feel they connect most appropriately with the overall picture. I have done the same with sections of the prose poem, *From the Waters of Babylon*.

There are three parts: Her People's History; Her Vision; Patriot of Freedom. The first is clearly the longest, since, as I have indicated, Lazarus' vision of Jewish regeneration emanates from Jewish history.

The Choice, perhaps the poem that best defines

Lazarus, is placed straight after the dedication. It is very much in tune with Jewish mysticism with its focus on the lamp and light, prime symbols for Lazarus of the Jewish mission. The selection proper opens with *Echoes*, a self-portrait of the one-time reclusive young woman, and a brief extract from *Epochs* in which Lazarus seems to be visualising her future work – and death.

Part I covers the themes of exile, Christian anti-semitism, the Spanish Golden Age and the Expulsion, and ends with different forms of Jewish experience in the post-enlightenment era, from ghetto and persecution in Russia and Rumania to the tortured ambivalence of Heine, forced to convert to make his way in the gentile world. This is effectively captured in Lazarus' essay. The section opens with the sonnet *Bar Kochba*, sandwiched between two extracts from *The Last National Revolt of the Jews*. The revolt, Bar Kochba the military commander and Rabbi Akiva the spiritual instigator are key icons in the Lazarus pantheon and recur frequently in her work. An example of Lazarus' translations from the Spanish Hebrew poets is the short but evocative *Longing for Jerusalem*.

Three of the several pieces on Christian antisemitism contain visionary elements. The extract from the fable *Raschi in Prague* [28] may be seen to foreshadow greater Christian-Jewish understanding. *The Guardian of the Red Disk* evoked immediately the yellow star Jews were forced to wear as recently as the Nazi era. [29] I have chosen two longish extracts from *The Dance to Death*. The speech by the blinded Rabbi Cresselin at the beginning gives an eerie foretaste of the burning synagogues and

roasting flesh of the early, less industrialised stages of the Holocaust. I have labelled this 'The Warning'. The last scene, which I have labelled 'Acceptance', conveys the dignity of the Jews as they approach death. It is also prophetic. [30]

The post-enlightenment era is also reflected in the American experience, from the bleak tribute to past glories – *In the Jewish Synagogue at Newport* – to the exhilaration of a new dawn – *In Exile*; prose extracts focus on post-Seligman antisemitism and on the rôle of the American Jew. A moving *exposé* of the tribulations of the ghetto and the daunting unfamiliarity of life in America is found in extracts from *The Jews of Barnow*.

Part II conveys Lazarus' vision of national rebirth – *The Valley of Baca*, *The New Ezekiel* – and calls for Jewry to reclaim the spirit of heroes like the Maccabees and Bar Kochba – *The Banner of the Jew*, *The Feast of Lights*. *The New Year* contains a distinct vision of the two directions the redeemed Jewish exiles will take: 'homeward' to the 'ancient source' and 'sunward' to the New World. Prose extracts call for support for Jewish nationhood and for spiritual and moral regeneration within American Jewry; other extracts show how the world could benefit from Judaism's fundamental principles of ethical monotheism.

Part III looks at Lazarus' concern with liberty, from her sympathetic identification with Byron to her call in *How Long* for American culture to free itself from bondage to the old country. *Sic Semper Liberatoribus* and *Sunrise* [31], both written in 1881, pay tribute to Czar Alexander II and President James Garfield who were both assassinated. The former condemns nihilism and both

contain unconscious portents of events to come: 1917 and the wave of patriotic feeling in the wake of the Kennedy assassination. The selection closes with Lazarus' sympathy with the socialist principles of William Morris and the economic reformer, Henry George, whose *Progress and Poverty* had greatly stirred her.

VIII

Among the flood of tributes unleashed by Emma Lazarus' death was a memorial edition of *The American Hebrew* on 9 December 1887 with contributions from prominent Jewish and literary figures on two continents. Eulogies referred to her as a biblical 'Miriam' and 'Deborah', as one who 'more than any other woman ... represented her people to the world at large, and by token of her own force and power ... seemed to lift the whole race of Israel in the public mind ...' [32] Memorial issues were also published by *The Critic* (10 December 1887) and *The Century* (October 1888). She was lauded as 'Sybil Judaica', [33] as 'poet and prophetess'. Eighteen years after her death she was memorialised in a sonnet as '... bard of the ancient people/ Though being dead, thou speakest ...'. [34]

What would she have made of the century that followed which saw the themes that concerned her impact with such magnitude on the world stage? Could she have visualised the extent of the catastrophe that awaited the Jews of Europe? One cannot say. But surely she would have urged them to immigrate in their masses to Palestine *before* the doors were brutally closed.

Her call for American Jewry, for '*prosperous* [Jewry] of whatever nationality' [35] to come forward to help their

hapless coreligionists would have been needed during the Nazi era. [36] Only after the Holocaust did Jews of the free world unite in solidarity – on behalf of Israel, for example, or for freedom of emigration for Soviet Jewry. On the other hand, she would doubtless have been horrified to see her vision of Jewish power and influence twisted by antisemitic rhetoric into a world Jewish conspiracy.

She would have exalted in the resurrected nation of Bar Kochbas and Maccabees, in their military prowess, their scientific and technical ingenuity and in the primacy placed on physical labour in the early days. But she would have demanded that the Jewish nation should be a beacon of liberty, a light to the gentile world. She would have found the need to press for Jewish unity as urgent if not more so than in her time, seeing factionalism flourish both within the Jewish state and outside. And her call for the '*secularization* and spiritualising of the Jewish nationality', [37] with its emphasis on spirituality as opposed to ritual, remains as valid in our day as in hers.

As one who was praised for having 'the courage and logic of a man', [38] Emma Lazarus had clearly shed the 'late-born and woman-souled' disposition of her early days. As a Jewish patriot and social activist, she was able to work in cooperation with men as a respected equal.

Today, she would probably have remained the Jewish rebel she celebrated, 'endowed with a shrewd, logical mind …' [39], active in protest against injustice. [40]

EMMA KLEIN

ECHOES

Late-born and woman-souled I dare not hope,
The freshness of the elder lays, the might
Of manly, modern passion shall alight
Upon my Muse's lips, nor may I cope
(Who veiled and screened by womanhood must grope)
With the world's strong-armed warriors and recite
The dangers, wounds, and triumphs of the fight;
Twanging the full-stringed lyre through all its scope.
But if thou ever in some lake-floored cave
O'erbrowed by rocks, a wild voice wooed and heard,
Answering at once from heaven and earth and wave,
Lending elf-music to thy harshest word,
Misprize thou not these echoes that belong
To one in love with solitude and song.

From *Epochs*

WORK

Life is not a vision nor a prayer,
 But stubborn work; she may not shun her task.
After the first compassion, none will spare
 Her portion and her work achieved, to ask.
She pleads for respite, – she will come ere long
When, resting by the roadside, she is strong.

Nay, for the hurrying throng of passers-by
 Will crush her with their onward-rolling stream.
Much must be done before the brief light die;
 She may not loiter, rapt in this vain dream.
With unused trembling hands, and faltering feet,
She staggers forth, her lot assigned to meet.

But when she fills her days with duties done,
 Strange vigor comes, she is restored to health.
New aims, new interests rise with each new sun,
 And life still holds for her unbounded wealth.
All that seemed hard and toilsome now proves small,
And naught may daunt her, – she hath strength for all.

VICTORY

…

Nor will Death prove an all-unwelcome guest;
 The struggle has been toilsome to this end,
Sleep will be sweet, and after labor rest,
 And all will be atoned with him to friend.
Much must be reconciled, much justified,
And yet she feels she will be satisfied.

PART ONE

Her People's History

From
THE LAST NATIONAL REVOLT OF THE JEWS [1]

The Bar Kochba revolt, as it is commonly known, took place during the reign of the Emperor Hadrian after Judea had suffered a long time under Roman rule. Hadrian was insisting on imposing 'Pan-Athenaic' or Hellenistic customs and religious practice throughout the empire and was trying to force the Jews, the only people to resist, to worship Zeus. Jewish religious practice was severely restricted.

The key instigators in the revolt were the military leader, Bar Kochba, and Rabbi Akiva, the visionary sage who provided spiritual inspiration. At first the Jews were successful against local forces under Roman direction, but later the Romans sent powerful legions to quell the uprising.

One significant lesson of the revolt is that the Jews were willing to risk everything to preserve their religious independence. After the rebellion was brutally suppressed, the Jews were scattered throughout many countries and remained a people without a state for nearly two thousand years.

In the year 135 of the Christian Era, 3985 of the Jewish Calendar, occurred the final separation between the body and soul of Judaism, in other words, the definite extinction of Israel's national and political life and the beginning of its purely spiritual existence. The final death-struggle has a peculiar interest for American Jews, not merely because it was illustrated by deeds of heroic valor and endurance but because it represents the very principle of revolt and independence upon which our

present national state is based. On the day that Bethar fell the Jewish Idea, the idea of protest, of revolution against moral tyranny, of inviolable freedom of thought and conscience, disenthralled itself from the limits of a narrow plot of soil, to be dispersed and disseminated for beneficient action over the entire globe. As the first destruction of Jerusalem had scattered the Jewish seed all over the Orient, so from the final war with Hadrian dates the dispersion of the Jews over the West. This 'war of extermination,' as the Talmud calls it, a war of despair, undertaken by the smallest of nations against the greatest, could necessarily have but one end. But the courage and skill with which it was conducted are proved by the fact that despite tremendous odds it was prolonged through three years, and that Rome, in order to extinguish it, was forced to summon from a distant province her most illustrious general and her bravest legions. Its captain perished, sword in hand, its chief councillor, the sage Akiba, was tortured to death by the conquerors, the lives of half a million Jews were sacrificed in its support, and yet, in accordance with the world's customary ingratitude towards the unsuccessful brave, a cloud of neglect and obloquy has, until a very recent date, enshrouded the figure of its leader, Bar-Kochba....

BAR KOCHBA [2]

Weep, Israel! your tardy meed outpour
 Of grateful homage on his fallen head,
That never coronal of triumph wore,
 Untombed, dishonored, and unchapleted.
If Victory makes the hero, raw Success
 The stamp of virtue, unremembered
Be then the desperate strife, the storm and stress
 Of the last Warrior Jew. But if the man
Who dies for freedom, loving all things less,
 Against world-legions, mustering his poor clan;
The weak, the wronged, the miserable, to send
 Their death-cry's protest through the ages' span –
If such an one be worthy, ye shall lend
 Eternal thanks to him, eternal praise.
Nobler the conquered than the conqueror's end!

From
THE LAST NATIONAL REVOLT OF THE JEWS [3]

A dismembered nation, a territory laid waste and usurped by the stranger, a prohibited religion, a Temple blotted from the earth, a capital wiped out of existence in name and fact and a decimated tribe of exiles and slaves – such were the immediate results of the last fatal revolt of the Jews in 135. The sternest laws were enforced for the suppression of the faith, and Judaism in self-defense was obliged to limit the prohibitions of its code to idolatry, unchastity and murder. The use of phylacteries, the reading of a Bible-scroll, the wearing of a Jewish costume were, if detected, followed by corporal punishment, a heavy fine, or sometimes even by death. Needless to say that the observance of the Sabbath and circumcision were stringently forbidden. One can easily imagine Hadrian's fancying that he had forever rid the world of these obnoxious rebels, and that the name of Jew would soon vanish from the annals of the living. But no! through all history was to run the dark, rich stream of Jewish life and thought, sometimes dwindling into a mere pulsing thread, sometimes broadening into a powerful current, intersecting or flowing parallel with all the great historic streams, never losing its peculiar force and virtue any more than the Gulf Stream is lost in the multitudinous waters of the Atlantic. That the extinction of national life was not followed by the extermination or assimilation of the Jewish people is due mainly to the foresight of Rabbi Akiba. The whole life of this sage was absorbed by the endeavor to free his people and to strengthen Jewish institutions, in

order to render them invulnerable against external shock. He invented the Kabbala, which afforded a practical and useful method of communication, as it were, a cipher-correspondence between the scattered Jewish communities. [4] He zealously continued the work begun by Hillel, of writing out, codifying and arranging the oral Law – or Talmud –, thus erecting a 'living hedge' around the sacred institutions of the Bible. When, therefore, the doom fell upon Judaea, the fugitives who escaped were enabled to carry with them all that was vital and essential to Judaism. Armed with the Bible and the Talmud, they could virtually defy persecution. Though willing to shed their last drop of blood in defense of the sacred soil, yet they were wise enough to perceive that not the soil itself, but the Idea that fecundated and sanctified it, was the main prize. Israel went forth from that last horrible carnage with Jerusalem in the palm of his hand, with all Palestine set as a seal upon his heart. He seems to say, 'not upon material wealth, not upon noble cities and flourishing industries, not upon rich harvests and world-wide commerce depends the life of a People – but upon the impalpable Thought, the spiritual Hope, the immortal Idea.'

It is difficult to avoid using the language of supernaturalism in speaking of the Jews, but laying aside all theories of miraculous interposition and special divine guidance, it seems to have been necessary, in the progress of the human race, for a single people to prove by their very survival that the Idea is the life, that man exists by the truth, for the truth and through the truth. 'And he humbled thee and suffered thee to hunger ... in order that he might make thee know that man doth not live by bread

alone, but by every word that proceedeth out of the mouth of the Lord doth man live.' (Deut. 8:3)

Thus when the Jews were despoiled of every earthly possession, they became the 'People of the Book,' as the Moslems call them today. When, after prodigies of valor and endurance, they found it impossible to maintain their political independence, they exclaimed: 'Wherever we may find a resting-place for the sole of our foot, there will we stand to protest against intellectual and moral tyranny, to represent the right of every human being to worship God according to the dictates of his own conscience.' Thus they have dwelt among all nations, from Cochin-China to our own Republic, without territory, without sovereign or pontiff, without soldiers or ships, the most compact, enduring and indomitable force in history. Though they have inviolably maintained their peculiar individualism and jealously guarded their defenses, yet we all know how potently they have influenced modern thought and life. Through Maimonides, Reuchlin [5], Spinoza, Ricardo, Lassalle, they have given impetus and direction to some of the greatest intellectual and political movements of the world, besides having originated the present system of finance, 'through the invention and consolidation of the principles of commercial credit,' and having enriched the literature of every modern language with their talent. But while the debt of civilization to the Jew remains as immense as its ingratitude, our chief concern today is to consider what the Jews themselves have lost by the lack of national organization. It were vain to dispute that they are no longer characterized by that superb physical vigor which made the army of Bar-Kochba the terror of Rome itself. They have lost,

moreover, in their prolonged dispersion whatever capacity they originally possessed for united, harmonious action. Isolated as they were for so many centuries from the healthy activities of the peoples around them, they have been thrown back upon a purely intellectual existence, bearing as its higher fruits the great poets, philosophers, financiers – in its lower manifestations producing the petty tradesmen, peddlars, pawnbrokers, 'middlemen', of all classes. 'Living by their wits' has become one of the standing reproaches thrust upon them, and they have suffered from all the physical and material disadvantages resulting from their neglect (whether enforced or voluntary) of the various handicrafts and agricultural occupations. Thus they have become a puny-framed and feeble-handed folk, and there can be no doubt that their lack of material power and central authority tempts the semi-civilized populations of Europe to indulge in those violent outbreaks against them which we have lately had such frequent cause to deplore.

I have said the last national struggle of the Jews had a peculiar interest for American Israelites. In that little Judaic tribe, wrestling for freedom with the invincible tyrant of the world, I see the spiritual fathers of those who braved exile and death for conscience's sake, to found upon the New England rocks, within the Pennsylvania woods, over this immense continent, the Republic of the West. I see in Bar-Kochba, the ignored, despised, defeated Jewish soldier, the same passion of patriotism which, under more fortunate conditions, made illustrious a William of Orange, a Mazzini, a Garibaldi, a Kossuth, a Washington. Nay, more, I see in that protest of monotheism and moral purity against the corruptions and idolatry

of Rome, the initial seed of revolt that blossomed in Luther, in Reuchlin and Erasmus, and that will never cease to flourish and expand till all humanity recognises that God is One and His name is One. Do I seem to claim too much? Ask the Puritans, ask the Italian or the Hungarian emancipator; ask the leaders of the Reformation whence they drew their most profound and convincing accents, and they will point not to their own Testament, but to the Hebrew Bible. And it is because I believe that no blow struck for freedom and truth, futile though it may appear at the time, has ever utterly miscarried or failed to kindle in another heart a spark of the fire which prompted it – because of this I have chosen to linger upon the last irremediable defeat of the Jews, a defeat which ultimately resulted in the highest of spiritual victories.

From THE JEWISH PROBLEM [6]

During the first century of Christianity the Jews lived on the friendliest terms with the Christians, their religious systems having sprung from a common root, while the only difference of opinion between them concerned the question of the Messiahship. It was left for a later age, when the facts of the case were less clear in the world's memory, to hold the Jews guilty of the crucifixion.... Modern historians (Christian no less than Jewish) agree that the wide diffusion of Judaism was one of the chief elements in the rapid propagation of Christianity. The Christians of the first century after Jesus were already divided into two sects, viz: Jewish Christians and Pagan or Hellenistic Christians. The former were scarcely to be distinguished from the Jews proper. They regarded Jesus as a great and holy man, descended in a perfectly natural manner from King David, and they strictly observed the Jewish law, on the authority of Jesus himself, who said 'I am not come to destroy (the law), but to fulfill.'

LONGING FOR JERUSALEM [7]

Oh, city of the world, with sacred splendor blest,
My spirit yearns to thee from out the far-off West,
A stream of love wells forth when I recall thy day,
Now is thy temple waste, thy glory passed away.
Had I an eagle's wings, straight would I fly to thee,
Moisten thy holy dust with wet cheeks streaming free.
Oh, how I long for thee! albeit thy King has gone,
Albeit where balm once flowed, the serpent dwells alone.
Could I but kiss thy dust, so would I fain expire,
As sweet as honey then, my passion, my desire!

From *By the Waters of Babylon*

'Little Poems in Prose'

TREASURES

1. Through cycles of darkness the diamond sleeps in its coal-black prison.

2. Purely incrusted in its scaly casket, the breath-tarnished pearl slumbers in mud and ooze.

3. Buried in the bowels of earth, rugged and obscure, lies the ingot of gold.

4. Long hast thou been buried, O Israel, in the bowels of the earth; long hast thou slumbered beneath the overwhelming waves; long hast thou slept in the rayless house of darkness.

5. Rejoice and sing, for only thus couldst thou rightly guard the golden knowledge, Truth, the delicate pearl and the adamantine jewel of the Law.

THE WORLD'S JUSTICE

If the sudden tidings came
 That on some far, foreign coast,
Buried ages long from fame,
 Had been found a remnant lost
Of that hoary race who dwelt
 By the golden Nile divine,
Spoke the Pharaoh's tongue and knelt
 At the moon-crowned Isis' shrine –
How at reverend Egypt's feet,
Pilgrims from all lands would meet!

If the sudden news were known,
 That anigh the desert-place
Where once blossomed Babylon,
 Scions of a mighty race
Still survived, of giant build,
 Huntsmen, warriors, priest and sage,
Whose ancestral fame had filled,
 Trumpet-tongued, the earlier age,
How at old Assyria's feet
Pilgrims from all lands would meet!

Yet when Egypt's self was young,
 And Assyria's bloom unworn,
Ere the mythic Homer sung;
 Ere the gods of Greece were born,
Lived the nation of one God,
 Priests of freedom, sons of Shem,
Never quelled by yoke or rod,
 Founders of Jerusalem –
Is there one abides to-day,
Seeker of dead cities, say!

Answer, now as then, *they are*;
 Scattered broadcast o'er the lands,
Knit in spirit nigh and far,
 With indissoluble bands.
Half the world adores their God,
 They the living law proclaim,
And their guerdon is – the rod,
 Stripes and scourgings, death and shame.
Still on Israel's head forlorn,
Every nation heaps its scorn.

Emma Lazarus

From THE JEWISH PROBLEM

The Jewish problem is as old as history, and assumes in each age a new form. The life or death of millions of human beings hangs upon its solution; its agitation revives the fiercest passions for good and for evil that inflame the human breast. From the era when the monotheistic, Semitic slaves of the Pharaohs made themselves hated and feared by their polytheistic masters, till to-day when the monstrous giants Labor and Capital are arming for a supreme conflict, the Jewish question has been inextricably bound up with the deepest and gravest questions that convulse society. Religious intolerance and race-antipathy are giving place to an equally bitter and dangerous social enmity. This scattered band of Israelites, always in the minority, always in the attitude of *protestants* against the dominant creed, against society as it is, seem fated to excite the antagonism of their fellow-countrymen.

GIFTS

'O World-God give me Wealth!' the Egyptian cried.
His prayer was granted. High as heaven, behold
Palace and pyramid; the brimming tide
Of lavish Nile washed all his land with gold.
Armies of slaves toiled ant-wise at his feet,
World-circling traffic roared through mart and street,
His priests were gods, his spice-balmed kings enshrined,
Set death at naught in rock-ribbed charnels deep.
Seek Pharaoh's race to-day and ye shall find
Rust and the moth, silence and dusty sleep.

'O World-God, give me Beauty!' cried the Greek.
His prayer was granted. All the earth became
Plastic and vocal to his sense; each peak,
Each grove, each stream, quick with Promethean flame,
Peopled the world with imaged grace and light.
The lyre was his, and his the breathing might
Of the immortal marble, his the play
Of diamond-pointed thought and golden tongue.
Go seek the sun-shine race, ye find to-day
A broken column and a lute unstrung.

Emma Lazarus

'O World-God, give me Power!' the Roman cried.
His prayer was granted. The vast world was chained
A captive to the chariot of his pride.
The blood of myriad provinces was drained
To feed that fierce, insatiable red heart.
Invulnerably bulwarked every part
With serried legions and with close-meshed code,
Within, the burrowing worm had gnawed its home,
A roofless ruin stands where once abode
The imperial race of everlasting Rome.

'O Godhead, give me Truth!' the Hebrew cried.
His prayer was granted; he became the slave
Of the Idea, a pilgrim far and wide,
Cursed, hated, spurned, and scourged with none to save.
The Pharoahs knew him, and when Greece beheld,
His wisdom wore the hoary crown of Eld.
Beauty he hath forsworn, and wealth and power.
Seek him to-day, and find in every land.
No fire consumes him, neither floods devour;
Immortal through the lamp within his hand.

From *By the Waters of Babylon*

THE SOWER

1. Over a boundless plain went a man, carrying seed.

2. His face was blackened by sun and rugged from tempest, scarred and distorted by pain. Naked to the loins, his back was ridged with furrows, his breast was plowed with stripes.

3. From his hand dropped the fecund seed.

4. And behold, instantly started from the prepared soil a blade, a sheaf, a springing trunk, a myriad-branching, cloud-aspiring tree. Its arms touched the ends of the horizon, the heavens were darkened with its shadow.

5. It bare blossoms of gold and blossoms of blood, fruitage of health and fruitage of poison; birds sang amid its foliage, and a serpent was coiled about its stem.

6. Under its branches a divinely beautiful man, crowned with thorns, was nailed to a cross.

7. And the tree put forth treacherous boughs to strangle the Sower; his flesh was bruised and torn, but cunningly he disentangled the murderous knot and passed to the eastward.

8. Again there dropped from his hand the fecund seed.

9. And behold, instantly started from the prepared soil a blade, a sheaf, a springing trunk, a myriad-branching, cloud-aspiring tree. Crescent shaped like little emerald moons were the leaves; it bare blossoms of silver and blossoms of blood, fruitage of health and fruitage of poison; birds sang amid its foliage and a serpent was coiled about its stem.

10. Under its branches a turbaned mighty-limbed Prophet brandished a drawn sword.

11. And behold, this tree likewise puts forth perfidious arms to strangle the Sower; but cunningly he disentangles the murderous knot and passes on.

12. Lo, his hands are not empty of grain, the strength of his arm is not spent!

13. What gem hast thou saved for the future, O miraculous Husbandman? Tell me, thou Planter of Christhood and Islam; tell me, thou seed-bearing Israel!

From RASCHI IN PRAGUE

Then Raschi, royal in his rags, began:
'Hear me, my liege!' At that commanding voice,
The Bishop, who with dazed eyes had perused
The grieved, wise, beautiful, pale face, sprang up,
Quick recognition in his glance, warm joy
Aflame on his broad cheeks. 'No more! No more!
Thou art the man! Give me the hand to kiss
That raised me from the shadow of the grave
In Jaffa's lazar-house! Listen, my liege!
During my pilgrimage to Palestine
I, sickened with the plague and nigh to death,
Languished 'midst strangers, all my crumbling flesh
One rotten mass of sores, a thing for dogs
To shy from, shunned by Christian as by Turk,
When lo! this clean-breathed, pure-souled, blessed youth,
Whom I, not knowing for an infidel,
Seeing featured like the Christ, believed a saint,
Sat by my pillow, charmed the sting from pain,
Quenched the fierce fever's heat, defeated Death;
And when I was made whole, had disappeared,
No man knew whither, leaving no more trace
Than a re-risen angel. This is he!'
Then Raschi who had stood erect, nor quailed
From glances of hot hate or crazy wrath,
Now sank his eagle gaze, stooped his high head,
Veiling his glowing brow, returned the kiss
Of brother-love upon the Christian's hand,
And dropping on his knees implored the three,
'Grace for my tribe! They are what ye have made.

If any be among them fawning, false,
Insatiable, revengeful, ignorant, mean –
And there are many such – ask your own hearts
What virtues ye would yield for planted hate,
Ribald contempt, forced, menial servitude,
Slow centuries of vengeance for a crime
Ye never did commit? Mercy for these!
Who bear on back and breast the scathing brand
Of scarlet degradation, who are clothed
In ignominious livery, whose bowed necks
Are broken with the yoke. Change these to men!
That were a noble witchcraft simply wrought,
God's alchemy transforming clods to gold.
If there be one among them strong and wise,
Whose lips anoint breathe poetry and love,
Whose brain and heart served ever Christian need –
And there are many such – for his dear sake,
Lest ye chance murder one of God's high priests,
Spare his thrice-wretched tribe! Believe me, sirs,
Who have seen various lands, searched various hearts,
I have yet to touch that undiscovered shore,
Have yet to fathom that impossible soul,
Where a true benefit's forgot; where one
Slight deed of common kindness sown yields not
As now, as here, abundant crop of love.
Every good act of man, our Talmud says,
Creates an angel, hovering by his side.
Oh! what a shining host, great Duke, shall guard
Thy consecrated throne, for all the lives
Thy mercy spares, for all the tears thy ruth
Stops at the source. Behold this poor old man,
Last of a line of princes, stricken in years,

As thy dead father would have been to-day.
Was that white beard a rag for obscene hands
To tear? a weed for lumpish clowns to pluck?
Was that benignant, venerable face
Fit target for their foul throats' voided rheum?
That wrinkled flesh made to be pulled and pricked,
Wounded by flinty pebbles and keen steel?
Behold the prostrate, patriarchal form,
Bruised, silent, chained. Duke, such is Israel!'
'Unbind these men!' commanded Vladislaw.
'Go forth and still the tumult of my town.
Let no Jew suffer violence. Raschi, rise!
Thou who hast served the Christ – with this priest's life,
Who is my spirit's counselor – Christ serves thee.
Return among thy people with my seal,
The talisman of safety. Let them know
The Duke's their friend. Go, publish the glad news!'

Emma Lazarus

From THE JEWISH PROBLEM

The Jew was usually forced to wear a badge or a peculiar costume, and in some places, branded on the chin in order to make him a more conspicuous mark for Christian contempt and hatred. He was imprisoned in ghettos, where he forgot the use of his mother-tongue and exchanged it for a Hebrew jargon which serves as a theme of amusement to the Jew haters of to-day and as a convincing proof that German Jews are no Germans. After being robbed of his lands, he was excluded from all trades and all manual occupation. One alone remained open to him – and this one was *forced upon him by law* – usury. The first Jew who lived by lending money on interest was the learned Rabbi Jacob Tam, of France, whom crusading hordes had plundered in 1146. He complained bitterly of the necessity that forced upon him such an occupation: 'We have been left no other branch of industry to support life and to pay the onerous taxes imposed upon us by our landed seigneurs.' Bernard de Clairvaux admonished his followers, during the second crusade, against persecuting the Jews, because, if the Jews were not there, he said, 'Christian usurers would deal more hardly by the people than the Jews did.'

From *The Guardian of the Red Disk*

SPOKEN BY A CITIZEN OF MALTA – 1300

No beard, blue-black, grizzled or Judas-colored,
May hide that damning little wafer-flame.
When one appears therewith, the urchins know
Good sport's at hand; they fling their stones and mud,
Sure of their game. But most the wisdom shows
Upon the unbelievers' selves; they learn
Their proper rank; crouch, cringe, and hide, – lay by
Their insolence of self-esteem; no more
Flaunt forth in rich attire, but in dull weeds,
Slovenly donned, would slink past unobserved;
Bow servile necks and crook obsequious knees,
Chin sunk in hollow chest, eyes fixed on earth
Or blinking sidewise, but to apprehend
Whether or not the hated spot be spied.
I warrant my Lord Bishop has full hands,
Guarding the Red Disk – lest one rogue escape!

From
The Dance to Death: A Historical Tragedy in Five Acts

This play is dedicated, in profound veneration and respect, to the memory of George Eliot, the illustrious writer, who did most among the artists of our day towards elevating and ennobling the spirit of Jewish nationality.

ACT I, SCENE 2
THE WARNING

The Synagogue crowded with worshippers. Among the women in the Gallery are discovered LIEBHAID VON ORB *and* CLAIRE CRESSELIN. *Below among the men,* SÜSSKIND VON ORB *and* REUBEN. *At the Reader's Desk,* RABBI JACOB. *Fronting the audience under the Ark of the Covenant stands a high desk, behind which is seen the white head of an old man bowed in prayer.* BARUCH *and* NAPHTALI *enter and take their seats.*

BARUCH
Think you he speaks before the service?

NAPTHALI
 Yea.
Lo, phantom-like the towering patriarch!

[RABBI CRESSELIN *slowly rises beneath the Ark.*]

RABBI CRESSELIN
Woe unto Israel! woe unto all

Abiding 'mid strange peoples! Ye shall be
Cut off from that land where ye made your home.
I, Cresselin of Chinon, have traveled far,
Thence where my fathers dwelt, to warn my race,
For whom the fire and stake have been prepared.
Our brethren of Verdun, all over France,
Are burned alive beneath the *Goyim's* torch.
What terrors have I witnessed, ere my sight
Was mercifully quenched! In Gascony,
In Savoy, Piedmont, round the garden shores
Of tranquil Leman, down the beautiful Rhine,
At Lindau, Costnitz, Schaffhausen, St Gallen,
Everywhere torture, smoking Synagogues,
Carnage, and burning flesh. The lights shine out
Of Jewish virtue, Jewish truth, to star
The sanguine field with an immortal blazon.
The venerable Mar-Isaac in Cologne,
Sat in his house at prayer, nor lifted lid
From off the sacred text, while all around
The fanatics ran riot; him they seized,
Haled through the streets, with prod of stick and spike
Fretted his wrinkled flesh, plucked his white beard,
Dragged him with gibes into their Church and held
A Crucifix before him. 'Know thy Lord!'
He spat thereon; he was pulled limb from limb,
I saw – God that I might forget! – a man
Leap in the Loire, with his fair, stalwart son,
A-bloom with youth, and midst the stream unsheathe
A poniard, sheathing it in his boy's heart,
While he pronounced the blessing for the dead.
'Amen!' the lad responded as he sank,
And the white water darkened as with wine.

Emma Lazarus

I saw – but no! You are glutted, and my tongue,
Blistered, refuseth to narrate more woe.
I have known much sorrow. When it pleased the Lord
To afflict us with the horde of *Pastoureaux*,
The rabble of armed herdsmen, peasants, slaves,
Men-beasts of burden – coarse as the earth they tilled,
Who like an inundation deluged France
To drown our race – my heart held firm, my faith
Shook not upon her rock until I saw,
Smit by God's beam, the big black cloud dissolve.
Then followed with their scythes, spades, clubs,
 and banners
Flaunting the Cross, the hosts of Armleder,
From whose fierce wounds we scarce are healed to-day.
Yet do I say the cup of bitterness
That Israel has drained is but a draught
Of cordial, to the cup that is prepared.
The Black Death and the Brothers of the Cross,
These are our foes – and these are everywhere.
I who am blind see ruin in their wake;
Ye who have eyes and limbs, arise and flee!
Tomorrow the Flagellants will be here.
God's angel visited my sleep and spake:
'Thy Jewish kin in the Thuringian town
Of Nordhausen shall be swept off from earth,
Their elders and their babes – consumed with fire.
Go, summon Israel to flight – take this
As sign that I, who call thee, am the Lord,
Thine eyes shalt be struck blind till thou hast spoken.'
Then darkness fell upon my mortal sense,
But light broke o'er my soul, and all was clear,
And I have journeyed hither with my child

O'er mount and river, till I have announced
The message of the Everlasting God.

[Sensation in the Synagogue.]

RABBI JACOB
Father, have mercy! when wilt thou have done
With rod and scourge? Beneath thy children's feet
Earth splits, fire springs. No rest, no rest! no rest.

A VOICE
Look to the women! Marianne swoons!

ANOTHER VOICE
Woe unto us who sinned!

ANOTHER VOICE
 We're all dead men.
Fly, fly ere dawn as our forefathers fled
From out the land of Egypt.

BARUCH
 Are ye mad?
Shall we desert snug homes? forego the sum
Scraped through laborious years to smooth life's slope,
And die like dogs unkenneled and untombed,
At bidding of a sorrow-crazed old man?

A VOICE
He flouts the Lord's anointed! Cast him forth!

SÜSSKIND VON ORB
Peace, brethren, peace! If I have ever served

Emma Lazarus

Israel with purse, arm, brain, or heart – now hear me!
May God instruct my speech! This wise old man,
Whose brow flames with the majesty of truth,
May be part-blinded through excess of light,
As one who eyes too long the naked sun,
Setting in rayless glory, turns and finds
Outlines confused, familiar colors changed,
All objects branded with one blood-bright spot.
Nor chafe at Baruch's homely sense; truth floats
Midway between the stars and the abyss.
We, by God's grace, have found a special nest
I' the dangerous rock, screened against wind and hawk;
Free burghers of a free town, blessed moreover
With the peculiar favor of the Prince,
Frederick the Grave, our patron and protector.
What shall we fear? Rather, where shall we seek
Secure asylum, if here be not one?
Fly? Our forefathers had the wilderness,
The sea their gateway, and the fire-cored cloud
Their divine guide. Us, hedged by ambushed foes,
No frank, free, kindly desert shall receive.
Death crouches on all sides, prepared to leap
Tiger-like on our throats, when first we step
From this safe covert. Everywhere the Plague!
As nigh as Erfurt it has crawled – the towns
Reek with miasma, the rank fields of spring,
Rain-saturated, are one beautiful – lie,
Smiling profuse life, and secreting death.
Strange how, unbidden, a trivial memory
Thrusts itself on my mind in this grave hour.
I saw a large white bull urged through the town
To slaughter, by a stripling with a goad,

Whom but one sure stamp of that solid heel,
One toss of those mooned horns, one battering blow
Of that square marble forehead, would have crushed,
As we might crush a worm, yet on he trudged,
Patient, in powerful health to death. At once,
As though o' the sudden stung, he roared aloud,
Beat with fierce hoofs the air, shook desperately
His formidable head, and heifer-swift,
Raced through scared, screaming streets. Well, and the
end?
He was the promptlier bound and killed and quartered.
The world belongs to man; dreams the poor brute
Some nook has been apportioned for brute life?
Where shall a man escape men's cruelty?
Where shall God's servant cower from his doom?
Let us bide, brethren – we are in His hand.

RABBI CRESSELIN
(uttering a piercing shriek)
Ah!
Woe unto Israel! Lo, I see again,
As the Ineffable foretold. I see
A flood of fire that streams towards the town.
Look, the destroying Angel with the sword,
Wherefrom the drops of gall are raining down,
Broad-winged, comes flying towards you. Now he draws
His lightning-glittering blade! With the keen edge
He smiteth Israel – ah!

[He falls back dead. Confusion in the Synagogue.]

CLAIRE
(from the gallery)
Father! My father!
Let me go down to him!

LIEBHAID

Sweet girl, be patient.
This is the House of God, and He hath entered.
Bow we and pray.

[Meanwhile, some of the men surround and raise from the ground the body of RABBI CRESSELIN. *Several voices speaking at once.]*

FIRST VOICE
He's doomed.

SECOND VOICE
Dead! Dead!

THIRD VOICE
A judgment!

FOURTH VOICE
Make way there! Air! Carry him forth! He's warm!

THIRD VOICE
Nay, his heart's stopped – his breath has ceased – quite dead.

FIFTH VOICE
Didst mark a diamond lance flash from the roof,
And strike him 'twixt the eyes?

FIRST VOICE
Our days are numbered.
This is the token.

RABBI JACOB
Lift the corpse and pray.
Shall we neglect God's due observances,
While He is manifest in miracle?
I saw a blaze seven times more bright than fire,
Crest, halo-wise, the patriarch's white head.
The dazzle stung my burning lids – they closed,
One instant – when they oped, the great blank cloud
Had settled on his countenance forever.
[8] Departed brother, mayest thou find the gates
Of heaven open, see the city of peace,
And meet the ministering angels, glad,
Hastening towards thee! May the High Priest stand
To greet and bless thee! Go thou to the end!
Repose in peace and rise again to life.
No more thy sun sets, neither wanes thy moon.
The Lord shall be thy everlasting light,
Thy days of mourning shall be at an end.
For you, my flock, fear nothing; it is writ
As one his mother comforteth, so I
Will comfort you and in Jerusalem
Ye shall be comforted.

[Scene closes.]

ACT V, SCENE 3
ACCEPTANCE

Within the Synagogue. Above in the gallery, women sumptuously attired; some with children by the hand or infants in their arms. Below the men and boys with silken scarfs about their shoulders.

RABBI JACOB
The Lord is nigh unto the broken heart. [9]
Out of the depths we cry to thee, oh God!
Show us the path of everlasting life;
For in thy presence is the plenitude
Of joy, and in thy right hand endless bliss.

[Enter SÜSSKIND, REUBEN, *etc.]*

SEVERAL VOICES
Woe unto us who perish!

A JEW
Süsskind von Orb,
Thou hast brought down this doom. Would we had heard
The prophet's voice!

SÜSSKIND
Brethren, my cup is full!
Oh let us die as warriors of the Lord.
The Lord is great in Zion. Let our death
Bring no reproach to Jacob, no rebuke
To Israel. Hark ye! let us crave one boon

At our assassins' hands; beseech them build
Within God's acre where our fathers sleep,
A dancing-floor to hide the fagots stacked.
Then let the minstrels strike the harp and lute,
And we will dance and sing above the pile,
Fearless of death, until the flames engulf,
Even as David danced before the Lord,
As Miriam danced and sang beside the sea.
Great is our Lord! His name is glorious
In Judah, and extolled in Israel!
In Salem is his tent, his dwelling place
In Zion; let us chant the praise of God!

A JEW
Süsskind, thou speakest well! We will meet death
With dance and song. Embrace him as a bride.
So that the Lord receive us in his tent.

SEVERAL VOICES
Amen! amen! amen! we dance to death!

RABBI JACOB
Süsskind, go forth and beg this grace of them.

[*Exit* SÜSSKIND.]

Punish us not in wrath, chastise us not
In anger, oh our God! Our sins o'erwhelm
Our smitten heads, they are a grievous load;
We look on our iniquities, we tremble,
Knowing our trespasses. Forsake us not.
Be thou not far from us. Haste to our aid,

Emma Lazarus

Oh God, who art our Saviour and our Rock!

[Re-enter SÜSSKIND.*]*

SÜSSKIND

Brethren, our prayer, being the last, is granted.
The hour approaches. Let our thoughts ascend
From mortal anguish to the ecstasy
Of martyrdom, the blessed death of those
Who perish in the Lord. I see, I see
How Israel's ever-crescent glory makes
These flames that would eclipse it, dark as blots
Of candle-light against the blazing sun.
We die a thousand deaths, – drown, bleed, and burn;
Our ashes are dispersed unto the winds.
Yet the wild winds cherish the sacred seed,
The waters guard it in their crystal heart,
The fire refuseth to consume. It springs,
A tree immortal, shadowing many lands,
Unvisited, unnamed, undreamed as yet.
Rather a vine, full-flowered, golden-branched,
Ambrosial-fruited, creeping on the earth,
Trod by the passer's foot, yet chosen to deck
Tables of princes. Israel now has fallen
Into the depths, he shall be great in time [10]
Even as we die in honor, from our death
Shall bloom a myriad heroic lives,
Brave through our bright example, virtuous
Lest our great memory fall in disrepute.
Is one among us brothers, would exchange
His doom against our tyrants, – lot for lot?
Let him go forth and live – he is no Jew.

Is one who would not die in Israel
Rather than live in Christ, – their Christ who smiles
On such a deed as this? Let him go forth –
He may die full of years upon his bed.
Ye who nurse rancor haply in your hearts,
Fear ye we perish unavenged? Not so!
Today, no! nor to-morrow! but in God's time,
Our witnesses arise. Ours is the truth,
Ours is the power, the gift of Heaven. We hold
His Law, His lamp, His covenant, His pledge.
Wherever in the ages shall arise
Jew-priest, Jew-poet, Jew-singer, or Jew-saint –
And everywhere I see them star the gloom –
In each of these the martyrs are avenged!

RABBI JACOB

Bring from the Ark the bell-fringed, silken-bound
Scrolls of the Law. Gather the silver vessels,
Dismantle the rich curtains of the doors,
Bring the Perpetual Lamp; all these shall burn,
For Israel's light is darkened, Israel's Law
Profaned by strangers. Thus the Lord hath said: [11]
'The weapon formed against thee shall not prosper,
The tongue that shall contend with thee in judgment,
Thou shalt condemn. This is the heritage
Of the Lord's servants and their righteousness.
For thou shalt come to peoples yet unborn,
Declaring that which He hath done. Amen!'

*[The doors of the Synagogue are burst open with tumul-
tuous noise.* CITIZENS *and others rush in.]*

Emma Lazarus

CITIZENS

Come forth! the sun sets. Come, the Council waits!
What! will ye teach your betters patience? Out!
The Governor is ready. Forth with you,
Curs! serpents! Judases! The bonfire burns!

[*Exeunt.*]

78

From THE JEWISH PROBLEM

Let us glance at the one sunny spot which shines forth
amid the mediaeval darkness. While the rest of Europe
was buried in superstition and barbarism, the dominion
of the Moors exempted a large part of Spain from the
influences of the Church. Here the intellectual and moral
development of the Jews had free scope, and we find them
consequently engaged in all branches of productive indus-
try – silk-merchants, dyers of purple, glass-manufactur-
ers, as well as superintendents of the noble colleges
founded by the Saracens, scholars, doctors, poets, states-
men, and philosophers....

Emma Lazarus

From AN EPISTLE TO THE HEBREWS X

The brief periods of liberty enjoyed by the Jews since the reign of Constantine have been signalized by extraordinary intellectual achievements on their part. Between the 10th and 13th centuries, their schools in Spain, Southern France and Italy were, by universal testimony, the foremost of the age in medicine, mathematics, astronomy, metaphysics and grammar. I have the authority of a Christian writer for stating it to be through the Jews that the science of medicine revived, while the schools of medicine proved the cradles and nurseries of physical science. The Jews were the universal translators, publishers and literary correspondents, through whom interchange of thought in secular matters was kept up.... The arrival of the Jews in the Low Countries and Italy after their expulsion from Spain did quite as much for the restoration of letters as the almost contemporary influx into Italy of the Greeks from Constantinople.... The part borne by the Jews in preparing the Reformation was acknowledged by both sides at the time. The students of Hebrew literature were the immediate precursors and in some cases the leaders of the Reformation in the 16th Century.

From AN EPISTLE

FROM JOSHUA IBN VIVES OF ALLORQUI TO HIS FORMER
MASTER, SOLOMON LEVI-PAUL, DE SANTA-MARIA, BISHOP OF
CARTAGENA, CHANCELLOR OF CASTILE, AND PRIVY COUN-
CILLOR TO KING HENRY III OF SPAIN. [12]

[In this poem I have done little more than elaborate and
versify the account given in Graetz's *History of the Jews*
(Vol. VIII, page 77) of an Epistle actually written in the
beginning of the fifteenth century by Joshua ben Joseph
Ibn Vives to Paulus de Santas Maria – E.L.]

II

Oft I recall that golden time when thou,
 Born for no second station, heldst with us
The Rabbi's chair, who art priest and bishop now;
 And we, the youth of Israel, curious,
Hung on thy counsels, lifted reverent brow
 Unto thy sanctity, would fain discuss
With thee our Talmud problems good and evil,
Till startled by the risen stars o'er Seville....

VII

To me, who, vine to stone, clung close to thee,
 The very base of life appeared to quake
When first I knew thee fallen from us, to be
 A tower of strength among our foes, to make
'Twixt Jew and Jew deep cloven enmity.
 I have wept gall and blood for thy dear sake.
But now with temperate soul I calmly search
Motive and cause that bound thee to the Church....

X

I saw thee mount with deprecating air,
 Step after step, unto our Jewish throne
Of supreme dignity, the Rabbi's chair;
 Shrinking from public honors thrust upon
Thy meek desert, regretting even there
 The placid habit of thy life foregone;
Silence obscure, vast peace and austere days
Passed in wise contemplation, prayer, and praise....

XIII

But thee no doubt confused, no problems vexed.
 Thy father's faith for thee proved bright and sweet.
Thou foundst no rite superfluous, no text
 Obscure; the path was straight before thy feet.
Till thy baptismal day, thou, unperplexed
 By foreign dogma, didst our prayers repeat,
Honor the God of Israel, fast and feast,
Even as thy people's wont, from first to least....

XVI

Was Israel glad in Seville on the day
 Thou didst renounce him? Then mightest thou indeed
Snap finger at whate'er thy slanderers say.
 Lothly must I admit, just then the seed
Of Jacob chanced upon a grievous way.
 Still from the wounds of that red year we bleed.
The curse had fallen upon our heads – the sword
Was whetted for the chosen of the Lord.

XVII

There where we flourished like a fruitful palm,
 We were uprooted, spoiled, lopped limb fron limb.
A bolt undreamed of out of heavens calm,
 So cracked our doom. We were destroyed by him
Whose hand since childhood we had clasped. With balm
 Our head had been anointed, at the brim
Our cup ran over – now our day was done,
Our blood flowed free as water in the sun....

XXII

Thou couldst not fear extinction for our race;
 Though Christian sword and fire from town to town
Flash double bladed lightning to efface
 Israel's image – though we bleed, burn, drown
Through Christendom – 'tis but a scanty space.
 Still are the Asian hills and plains our own,
Still are we lords in Syria, still are free,
Nor doomed to be abolished utterly.

XXIII

One sole conclusion hence at last I find,
 Thou whom ambition, doubt, nor fear could swerve,
Perforce hast been persuaded through the mind,
 Proved, tested the new dogmas, found them serve
Thy spirit's needs, left flesh and sense behind,
 Accepted without shrinking or reserve,
The trans-substantial bread and wine, the Christ
At whose shrine thine own kin were sacrificed....

XXV

Where are the signs fulfilled whereby all men
　　Should know the Christ? Where is the wide-winged
peace
Shielding the lamb within the lion's den?
　　The freedom broadening with the wars that cease?
Do foes clasp hands in brotherhood again?
　　Where is the promised garden of increase,
When like a rose the wilderness should bloom?
Earth is a battlefield and Spain a tomb....

XXXIV

Help me, O thou who wast my boyhood's guide,
　　I bend my exile-weary feet to thee,
Teach me the indivisible to divide,
　　Show me how three are one and One is three!
How Christ to save all men was crucified,
　　Yet I and mine are damned eternally.
Instruct me, Sage, why Virtue starves alone,
While falsehood step by step ascends the throne.

1492

Thou two-faced year, Mother of Change and Fate,
Didst weep when Spain cast forth with flaming sword,
The children of the prophets of the Lord,
Prince, priest, and people, spurned by zealot hate.
Hounded from sea to sea, from state to state,
The West refused them, and the East abhorred.
No anchorage the known world could afford,
Close-locked was every port, barred every gate.
Then smiling, thou unveil'dst, O two-faced year,
A virgin world where doors of sunset part,
Saying, 'Ho, all who weary, enter here!
There falls each ancient barrier that the art
Of race or creed or rank devised, to rear
Grim bulwarked hatred between heart and heart!'

From *By the Waters of Babylon* [13]

THE EXODUS
(3 August 1492)

1. The Spanish noon is a blaze of azure fire, and the dusty pilgrims crawl like an endless serpent along treeless plains and bleached high-roads, through rock-split ravines and castellated, cathedral-shadowed towns.

2. The hoary patriarch, wrinkled as an almond shell, bows painfully upon his staff. The beautiful young mother, ivory pale, well-nigh swoons beneath her burden; in her large enfolding arms nestles her sleeping babe, round her knees flock her little ones with bruised and bleeding feet. 'Mother, shall we soon be there?'

3. The youth with Christ-like countenance speaks comfortably to father and brother, to maiden and wife. In his breast, his own heart is broken.

4. The halt, the blind, are amid the train. Sturdy pack-horses laboriously drag the tented wagons wherein lie the sick athirst with fever.

5. The panting mules are urged forward with spur and goad; stuffed are the heavy saddle-bags with the wreckage of ruined homes.

6. Hark to the tinkling silver bells that adorn the tenderly carried silken scrolls.

7. In the fierce noon-glare a lad bears a kindled lamp; behind its network of bronze the airs of heaven breathe not upon its faint purple star.

8. Noble and abject, learned and simple, illustrious and obscure, plod side by side, all brothers now, all

merged in one routed army of misfortune.

9. Woe to the straggler who falls by the wayside! No friend shall close his eyes.

10. They leave behind, the grape, the olive, and the fig; the vines they planted, the corn they sowed, the garden-cities of Andalusia and Aragon, Estremadura and La Mancha, of Granada and Castile; the altar, the hearth, and the grave of their fathers.

1l. The townsman spits at their garments, the shepherd quits his flock, the peasant his plow, to pelt with curses and stones; the villager sets on their trail his yelping cur.

12. Oh the weary march, oh the uptorn roots of home, oh the blankness of the receding goal!

13. Listen to their lamentation: *They that ate dainty food are desolate in the streets; they that were reared in scarlet embrace dung-hills. They flee away and wander about. Men say among the nations, they shall no more sojourn there; our end is near, our days are full, our doom is come.*

14. Whither shall they turn? for the West hath cast them out, and the East refuseth to receive.

15. O bird of the air, whisper to the despairing exiles, that to-day, to-day, from the many-masted, gayly-bannered port of Palos, sails the world-unveiling Genoese, to unlock the golden gates of sunset and bequeath a Continent to Freedom!

IN THE JEWISH SYNAGOGUE AT NEWPORT

Here, where the noises of the busy town,
　　The ocean's plunge and roar can enter not,
We stand and gaze around with tearful awe,
　　And muse upon the consecrated spot.

No signs of life are here: the very prayers
　　Inscribed around are in a language dead;
The light of the 'perpetual lamp' is spent
　　That an undying radiance was to shed.

What prayers were in this temple offered up,
　　Wrung from sad hearts that knew no joy on earth,
By these lone exiles of a thousand years,
　　From the fair sunrise land that gave them birth!

Now as we gaze, in this new world of light,
　　Upon this relic of the days of old,
The present vanishes, and tropic bloom
　　And Eastern towels and temples we behold.

Again we see the patriarch with his flocks,
　　The purple seas, the hot blue sky o'erhead,
The slaves of Egypt, – omens, mysteries, –
　　Dark fleeing hosts by flaming angels led.

A wondrous light upon a sky-kissed mount,
　　A man who reads Jehovah's written law,
'Midst blinding glory and effulgence rare,
　　Unto a people prone with reverent awe.

The pride of luxury's barbaric pomp,
 In the rich court of royal Solomon –
Alas! we wake: one scene alone remains, –
 The exiles by the streams of Babylon.

Our softened voices send us back again
 But mournful echoes through the empty hall;
Our footsteps have a strange, unnatural sound,
 And with unwonted gentleness they fall.

The weary ones, the sad, the suffering,
 All found their comfort in the holy place,
And children's gladness and men's gratitude
 Took voice and mingled in the chant of praise.

The funeral and the marriage, now, alas!
 We know not which is sadder to recall;
For youth and happiness have followed age,
 And green grass lieth gently over all.

And still the sacred shrine is holy yet,
 With its lone floors where reverent feet once trod.
Take off your shoes as by the burning bush,
 Before the mystery of death and God.

27 July 1867

Emma Lazarus

THE SUPREME SACRIFICE

Well-nigh two thousand years hath Israel
 Suffered the scorn of man for love of God;
 Endured the outlaw's ban, the yoke, the rod,
With perfect patience. Empires rose and fell,
 Around him Nebo was adored and Bel;
Edom was drunk with victory, and trod
On his high places, while the sacred sod
 Was desecrated by the infidel.
His faith proved steadfast, without breach or flaw,
 But now the last renouncement is required.
His truth prevails, his God is God, his Law
 Is found the wisdom most to be desired.
Not his the glory! He, maligned, misknown,
Bows his meek head, and says, 'Thy will be done!'

From *By the Waters of Babylon*

THE TEST

1. Daylong I brooded upon the Passion of Israel.

2. I saw him bound to the wheel, nailed to the cross, cut off by the sword, burned at the stake, tossed into the seas.

3. And always the patient, resolute, martyr face arose in silent rebuke and defiance.

4. A Prophet with four eyes; wide gazed the orbs of the spirit above the sleeping eyelids of the senses.

5. A Poet, who plucked from his bosom the quivering heart and fashioned it into a lyre.

6. A placid-browed Sage, uplifted from earth in celestial meditation.

7. These I saw, with princes and people in their train; the monumental dead and the standard-bearers of the future.

8. And suddenly I heard a burst of mocking laughter, and turning, I beheld the shuffling gait, the ignominious features, the sordid mask of the son of the Ghetto.

Emma Lazarus

THE CROWING OF THE RED COCK

Across the Eastern sky has glowed
 The flicker of a blood-red dawn,
Once more the clarion cock has crowed,
 Once more the sword of Christ is drawn.
A million burning rooftrees light
The world-wide path of Israel's flight.

Where is the Hebrew's fatherland?
 The folk of Christ is sore bestead;
The Son of Man is bruised and banned,
 Nor finds whereon to lay his head.
His cup is gall, his meat is tears,
His passion lasts a thousand years.

Each crime that wakes in man the beast,
 Is visited upon his kind.
The lust of mobs, the greed of priest,
 The tyranny of kings, combined
To root his seed from earth again,
His record is one cry of pain.

When the long roll of Christian guilt
 Against his sires and kin is known,
The flood of tears, the life-blood spilt,
 The agony of ages shown,
What oceans can the stain remove,
From Christian law and Christian love?

Nay, close the book; not now, not here,
 The hideous tale of sin narrate,
Reechoing in the martyr's ear,
 Even he might nurse revengeful hate,
Even he might turn in wrath sublime,
With blood for blood and crime for crime.

Coward? Not he, who faces death,
 Who singly against worlds has fought,
For what? A name he may not breathe,
 For liberty of prayer and thought.
The angry sword he will not whet,
His nobler task is – to forget.

Emma Lazarus

VENUS OF THE LOUVRE

Down the long hall she glistens like a star,
The foam-born mother of Love, transfixed to stone,
Yet none the less immortal, breathing on.
Time's brutal hand hath maimed but could not mar.
When first the enthralled enchantress from afar
Dazzled mine eyes, I saw not her alone,
Serenely poised on her world-worshipped throne,
As when she guided once her dove-drawn car, –
But at her feet a pale, death-stricken Jew,
Her life adorer, sobbed farewell to love.
Here *Heine* wept! Here still he weeps anew,
Nor ever shall his shadow lift or move,
While mourns one ardent heart, one poet-brain,
For vanished Hellas and Hebraic pain.

From THE POET HEINE [14]

A fatal and irreconcilable dualism formed the basis of
Heine's nature, and was the secret cause not only of his
profound unhappiness, but of his moral and intellectual
inconsistencies. He was a Jew, with the mind and eyes of a
Greek. A beauty-loving, myth-creating pagan soul was
imprisoned in a Hebrew frame; or rather, it was twinned,
like the unfortunate Siamese, with another equally power-
ful soul, – proud, rebellious, oriental in its love of the
vague, the mysterious, the grotesque, and tragic with the
two-thousand-year-old Passion of the Hebrews. In Heine
the Jew there is a depth of human sympathy, a mystic
warmth and glow of imagination, a pathos, an enthusi-
asm, an indomitable resistance to every species of
bondage, totally at variance with the qualities of Heine
the Greek. On the other hand, the Greek Heine is a crea-
ture of laughter and sunshine, possessing an intellectual
clearness of vision, a plastic grace, a pure and healthy love
of art for art's own sake, with which the somber Hebrew
was in perpetual conflict. What could be the result of
imprisoning two such antagonistic natures in a single
body? What but the contradictions, the struggles, the
tears, the violences that actually ensued? For Heine had
preeminently the artist capacity of playing the spectator
to the workings of his own mind, and his mordant sar-
casm and merciless wit were but the expression of his own
sense of the internal incongruity.... To-day his muse is the
beautiful Herodias, the dove-eyed Shulamite; to-morrow
it will be the Venus Anadyomene, the Genius of blooming
Hellas. He laments the ruin of Jerusalem with the

heart-stirring accents of the prophets, he glorifies Moses, 'the great emancipator, the valiant rabbi of liberty, the terrible enemy of all servitude! What a glorious personage!' he exclaims. 'How small Mount Sinai looks when Moses stands on its summit!'

He confesses that in his youth he had never done justice to this great master, nor to the Hebrew people, – 'doubtless,' he says, 'on account of my Graeco-pagan nature, the partiality of my Athenian mind which abhorred the ascetism of Judaea. But my predilection for the Hellenic world has diminished since then. I see now that Greeks were only beautiful youths whilst the Jews were always men, and powerful, indomitable men, not only then, in antiquity, but even today, in spite of eighteen centuries of persecution and misery. I have learned to appreciate them since, and if all pride of birth were not an absurd contradiction, in the champion of the democratic principles of the revolution, the author of this book might boast that his ancestors belonged to the noble house of Israel, that he is descended from those martyrs who gave the world a God, who promulgated the eternal code of morality, and who have fought valiantly upon every battlefield of thought!'...

If we bear in mind this distinctly dual nature of Heine, we might partly understand how he, whom his enemies called 'a sybarite, whose sleep was disturbed by the fall of a rose leaf,' proved himself capable during the last ten years of his life of a sustained fortitude under bodily anguish that recalls the heroism of the martyrs. From this inherent self-contradiction sprang his alternations of enthusiasm and cynicism, of generosity and egotism.... Mr Matthew Arnold speaks of his 'inconceivable attacks

upon his enemies, his still more inconceivable attacks upon his friends.' We no longer wonder when we remember that his double nature impelled him to turn and rend on the morrow that which he had worshipped the day before ... no prejudices are sacred, no associations are reverend to him. Romanticism, Hellenism, Hebraism, Teutonism – he swears allegiance to each in turn, and invariably concludes with a mock and parody of each one....

There was one ideal object from which Heine's loyal devotion never swerved nor wavered through all the vagaries of his eccentric career – and this object was Germany. Harshly as he and all his race were treated by the fatherland, his sentiment for the German people, his affinity with the German genius, his affection for the language, the literature, the legends, the very soil of his native land continued in unbroken force through all his years of exile beneath the thin veneer of Gallicism and cosmopolitanism....

Heine made peculiarly his own the rich and lovely realm of German tradition and folklore.... He created anew the Lorelei of the Rhine and the Venus of the Wartburg.... Even in his own day he was accepted as a folk singer and his rhymes found their way to the heart of the people and the lips of the peasantry, side by side with the bird-like refrains of the mediaeval minstrels....

But it was the graft of a foreign tree that gave him his rich and spicy aroma, his glowing color, his flavor of the Orient. His was a seed sprung from the golden branch that flourished in Hebrew-Spain between the years 1000 and 1200. Whoever looks into the poetry of the mediaeval Spanish Jews will see that Heine, the modern, cynical

German-Parisian, owns a place among these devout and ardent mystics who preceded him by fully eight centuries....

Heine is too sincere a poet to be accused of plagiarism, but there can be no doubt that, imbued as he was with the spirit of his race, revering so deeply their seldom-studied poetic legacy, he at times unwittingly repeated the notes which rang so sweetly in his ears. What the world thought distinctively characteristic of the man was often simply a mode of expression peculiar to his people at their best....

But it would convey a false impression to insist unduly upon the Hebrew element in Heine's genius, or to deduce therefrom that he was religiously at one with his people. His sympathy with them was a sympathy of race, not of creed, and, as we have said, it alternated with an equally strong revulsion in favor of Greek forms and ideas of beauty. Nor did it ever restrain him from showering his pitiless arrows of ridicule upon the chosen race....

It was impossible that the inharmonious elements combined in Heine's personality should ever properly affiliate and result in a sound, symmetric whole. His song is but the natural expression of the inward dissonance.... Poor Heine! I stood last summer by the grave of this free song-bird of the German forest. He lies in the stony heart of Paris.... Far from the parents whom he had loved with the passionate intensity of the Jew, far from his kinsfolk and the friends of his youth, surrounded by strangers to whom the very name on the tombstone is an unpronounceable, barbaric word, – he seems even in death an exile and outcast.

Yet no! Even now, more than a quarter of a century after his death, perhaps he is better thus....

The day before I visited his tomb the barrier-wall between the Jewish and Christian portions of the cemetery of Montmarte had been demolished by order of the French Government. As I saw the rubbish and wreck left by the work of humane destruction, I could not but reflect with bitterness that the day had not yet dawned beyond the Rhine, when Germany, free from race-hatred and bigotry, is worthy and ready to receive her illustrious Semitic son.

From TO CARMEN SYLVA

Yet who is he who pines apart,
Estranged from that maternal heart,
Ungraced, unfriended, and forlorn,
 The butt of scorn?
An alien in his land of birth,
An outcast from his brethren's earth,
Albeit with theirs his blood mixed well
 When Plevna fell?

When all Roumania's chains were riven,
When unto all his sons was given
The hero's glorious reward,
 Reaped by the sword, –
Wherefore was this poor thrall, whose chains
Hung heaviest, within whose veins
The oldest blood of freedom streamed,
 Still unredeemed?

O Mother, Poet, Queen in one!
Pity and save – he is thy son.
For poet David's sake, the king
 Of all who sing;
For thine own people's sake who share
His law, his truth, his praise, his prayer;
For his sake who was sacrificed –
 His brother – Christ!

From
RUSSIAN CHRISTIANITY
VERSUS MODERN JUDAISM [15]

Let us first disabuse our readers of the sophistical distinction made by Mme Ragozin, in common with many other writers, between the 'two kinds of Jews,' and the idea that 'a vast dualism essentially characterizes this extraordinary race.' Behind this subtle error lurk all the dangers that have threatened the existence of the people, for whatever calumnies be refuted by a Jewish spokesman, the answer is ever ready: 'These charges do not apply to you, and such as you. But how can you be sure that such outrages are not committed by some barbarous sect of your tribe?' Now, we *can* be sure of the Jews – more so, perhaps, than of any other people in the world, their history being the oldest among civilized nations, their social and moral code having remained unaltered through all time, and the vicissitudes of their fate having exposed them to almost every test which can affect individual or national character. The dualism of the Jews is the dualism of humanity; they are made up of the good and the bad. May not Christendom be divided into those Christians who denounce such outrages as we are considering, and those who commit or apologize for them? Immortal genius and moral purity, as exemplified by Moses and Spinoza, constitute a minority among the Jews, as they do among the Gentiles, but here ends the truth of the matter.

Emma Lazarus

From THE JEWISH PROBLEM

The insatiable thirst of the Jews is not for money, as calumniously asserted, but for knowledge. In those districts of Poland and Russia where they are refused admittance to the schools, they have had books of natural science and Darwinian treatises translated into Hebrew in order to follow the intellectual movement of the age.... The first use they make of their freedom invariably is to embrace all methods of higher instruction, and to strive toward a more complete intellectual development.

From *An Epistle to the Hebrews* XIII

THE JEWS OF BARNOW

These powerful and dramatic tales [16] introduce us into the social environment whence the unhappy refugees have emerged; and we see for ourselves the antiquated, semi-barbarous customs, the mental darkness, the petrified superstitions which have afforded so many convenient pretexts for pillage, arson and massacre....

I, for one, see no reason why the most enlightened of our race should blush in perusing the volume. Rather do I find cause for deepest thankfulness that formalism, superstition and austerity are the worst sins begotten in our people by the most odious of tyrannies; that intellectual ambition, pride of race and loyalty to a glorious past, glow unquenched even in this noisome atmosphere where we might reasonably expect the vices of slaves and the degradation of Helots. Even here flourish the immemorial virtues of the Jew – continence, sobriety, benevolence toward the poor, justice and piety. Neither the whip of the Pole, nor the glittering seductions of proffered freedom and equality, can crush or bribe this indomitable people, who are waiting but the opening of their Ghetto gates to emerge into that intellectual arena where their more fortunate co-religionists of other countries are already distinguished....

Viewed in this light, one of their most striking characteristics is their extraordinary power of moral endurance.

Emma Lazarus

From AN EPISTLE TO THE HEBREWS XI

However degrading or servile might be their avocations during the secular week, the first star of the Sabbath eve restored to them their human dignity, when they met in the Synagogue or around the family board, however humble, to sing, in the midst of bondage and oppression, those Psalms which have been for all ages the battle cry of freedom, and to cherish the memory of days when they were a nation of princes and priests. The Sabbath was distinguished from the weekday by holiday apparel, by convivial gatherings, by music and gayety; the only limit to these was the equal right of every individual to undisturbed rest from labor.

From *By the Waters of Babylon*

CURRENTS

1. Vast oceanic movements, the flux and reflux of immeasurable tides oversweep our continent.

2. From the far Caucasian steppes, from the squalid Ghettos of Europe,

3. From Odessa and Bucharest, from Kief and Ekaterinoslav, [17]

4. Hark to the cry of the exiles of Babylon, the voice of Rachel mourning for her children, of Israel lamenting for Zion.

5. And lo, like a turbid stream, the long-pent flood bursts the dykes of oppression and rushes hitherward.

6. Unto her ample breast, the generous mother of nations welcomes them.

7. The herdsman of Canaan and the seed of Jerusalem's royal shepherd renew their youth amid the pastoral plains of Texas and the golden valleys of the Sierras.

Emma Lazarus

IN EXILE

'Since that day till now our life is one unbroken paradise.
We live a true brotherly life. Every evening after supper we
take a seat under the mighty oak and sing our songs.'
– *Extract from a letter of a Russian refugee in Texas.* [18]

Twilight is here, soft breezes bow the grass,
 Day's sounds of various toil break slowly off,
The yoke-freed oxen low, the patient ass
 Dips his dry nostril in the cool, deep trough.
Up from the prairie the tanned herdsmen pass
 With frothy pails, guiding with voices rough
Their udder-lightened kine. Fresh smells of earth,
The rich, black furrows of the glebe send forth.

After the Southern day of heavy toil,
 How good to lie, with limbs relaxed, brows bare
To evening's fan, and watch the smoke-wreaths coil
 Up from one's pipe-stem through the rayless air.
So deem these unused tillers of the soil,
 Who stretched beneath the shadowing oak-tree, stare
Peacefully on the star-unfolding skies,
And name their life unbroken paradise.

The hounded stag that has escaped the pack,
 And pants at ease within a thick-leaved dell;
The unimprisoned bird that finds the track
 Through sun-bathed space, to where his fellows dwell;
The martyr, granted respite from the rack,
 The death-doomed victim pardoned from his cell, –

Such only know the joy these exiles gain, –
Life's sharpest rapture is surcease of pain.

Strange faces theirs, where through the Orient sun
 Gleams from the eyes and glows athwart the skin.
Grave lines of studious thought and purpose run
 From curl-crowned forehead to dark-bearded chin.
And over all the seal is stamped thereon
 Of anguish branded by a world of sin,
In fire and blood through ages on their name,
Their seal of glory and the Gentiles' shame.

Freedom to love the law that Moses brought,
 To sing the songs of David, and to think
The thoughts Gabirol to Spinoza taught,
 Freedom to dig the common earth, to drink
The universal air – for this they sought
 Refuge o'er wave and continent, to link
Egypt with Texas in their mystic chain,
And truth's perpetual lamp forbid to wane.

Hark! through the quiet evening air, their song
 Floats forth with wild sweet rhythm and glad refrain.
They sing the conquest of the spirit strong,
 The soul that wrests the victory from pain;
The noble joys of manhood that belong
 To comrades and to brothers. In their strain
Rustle of palms and Eastern streams one hears,
And the broad prairie melts in mist of tears.

Emma Lazarus

From *An Epistle to the Hebrews* XIII

THE JEWS OF BARNOW

One of the most zealous workers in behalf of the Russian refugees told me that last summer he sat at the close of a hot July day in the Emigrant Aid office, looking out upon the refreshing splendor of the golden sunset over the Battery and the Bay. Vainly did he try to awaken in the minds of the poor wretches around him a sense of the glory shining in their very eyes. And yet they were neither blind nor dead; they were simply stupefied by the appalling terrors of starvation, disgrace and destitution menacing themselves and their families. Who of us, under similar circumstances, would be susceptible to the tender beauty of a sun-lit cloud?...

By our own difficulty in entering into this strange, out-landish atmosphere, we may partly gauge the far greater difficulty experienced by the wretched refugees in adapting themselves to their rude and sudden transplantation into our Western world. If they appear dazed or stupefied by the unaccustomed light, or bewildered by the novel rush of free and healthy human activities, let us bear in mind the miserable nooks and alley-ways where they were so long imprisoned by despotism, and whence they are now driven forth by persecution....

What they need to bring them out of their abject condition, is neither military discipline, nor contemptuous ridicule, but justice, patience, liberty and light.

THE NEW COLOSSUS [19]

Not like the brazen giant of Greek fame,
With conquering limbs astride from land to land;
Here at our sea-washed, sunset gates shall stand
A mighty woman with a torch, whose flame
Is the imprisoned lightning, and her name
Mother of Exiles. From her beacon-hand
Glows world-wide welcome; her mild eyes command
The air-bridged harbor that twin cities frame.
'Keep, ancient lands, your storied pomp!' cries she
With silent lips. 'Give me your tired, your poor,
Your huddled masses yearning to breathe free,
The wretched refuse of your teeming shore.
Send these, the homeless, tempest-tost to me,
I lift my lamp beside the golden door!'

Emma Lazarus

From THE JEWISH PROBLEM

Even in America, presumably the refuge of the oppressed, public opinion has not yet reached that point where it absolves the race from the sin of the individual. Every Jew, however honorable or enlightened, has the humiliating knowledge that his security and reputation are, in a certain sense, bound up with those of the meanest rascal who belongs to his tribe, and who has it in his power to jeopardize the social status of his whole nation. It has been well said that the Jew must be of gold in order to pass for silver....

Here, too, the everlasting prejudice is cropping out in various shapes. Within recent years, Jews have been 'boycotted' at not a few places of public resort; in our schools and colleges, even in our scientific universities, Jewish scholars are frequently subjected to annoyance on account of their race. The word 'Jew' is in constant use, even among so-called refined Christians, as a term of opprobrium, and is employed as a verb, to denote the meanest tricks. In other words, all the magnanimity, patience, charity, and humanity, which the Jews have manifested in return for centuries of persecution, have been thus far inadequate to eradicate the profound antipathy engendered by fanaticism and ready to break out in one or another shape at any moment of popular excitement.

From AN EPISTLE TO THE HEBREWS V

The second point on which I desire to insist is that our own people, in default of sufficient acquaintance with the wellsprings of our national life and literature, are apt to be misled by the random assertions of Gentile critics, and are often only too apt to acquiesce in their fallacious statements. 'Tell a man he is brave, and you help him to become so,' says Carlyle, and the converse proposition is equally true. Our adversaries are perpetually throwing dust in our eyes with accusations of materialism and tribalism, and we in our pitiable endeavor to conform to the required standard, plead guilty and fall into the trap they set....

'Tribal!' This perpetual taunt rings so persistently in our ears that most Jews themselves are willing to admit its justice, in face of the fact that our 'tribal God' has become the God of two-thirds of the inhabited globe, the God of Islam and of Christendom, and that as a people we have adapted ourselves to the varying customs and climates of every nation in the world. In defiance of the hostile construction that may be put upon my words, I do not hesitate to say that our national defect is that we are not 'tribal' enough; we have not sufficient solidarity to perceive that when the life and property of a Jew in the uttermost provinces of the Caucasus are attacked, the dignity of a Jew in free America is humiliated.

Emma Lazarus

From AN EPISTLE TO THE HEBREWS XII

Yes, we have not only survived the unparallelled vicissi-
tudes to which we have been exposed, but on this remote
continent, where so many storm-tost European outcasts
have found freedom and peace, we have prospered to such
a degree as almost to forget the terrors of the tempest. But
a wail of lamentation reaches us from distant countries,
and to our grief and amazement we hear that other home-
less and despoiled survivors of that wreck in which we
suffered are subjected to renewed misery at the hands of
powerful oppressors. Shall we remain deaf to their cry, or
heeding the unanimous voice of friend and foe in counsel
or in menace, shall we not rather exert ourselves to render
feasible the only remedy applicable to the evil? A home for
the homeless, a goal for the wanderer, an asylum for the
persecuted, a nation for the denationalized. Such is the
need of our generation.... There is a general and deeply-
rooted feeling among American Jews, that the question
does not touch us.... What have we to do with the land-
less, denationalised Poles, Hungarians and Prussians,
unfamiliar with our language or customs and our ma-
terial interests? By exerting ourselves in their behalf and
assuming the responsibility of their misfortunes, we can
only compromise in the eyes of our fellow-citizens our
own loyalty to the flag that ensures us against similar
calamities. These are the objections urged by a narrow
selfishness and a short-sighted materialism: they take no
account of the fact that a crisis has arrived in Jewish his-
tory, presenting for millions of Jews the sharp alternative
of extinction or separation....

It will be a lasting blot upon American Judaism – nay, upon *prosperous* Judaism of whatever nationality – if we do not come forward now with encouragement for the disheartened and help for the helpless, or if we neglect this opportunity to dignify our race and our name by vigorous, united and disinterested action. To fail in such an attempt is no disgrace – the disgrace is in not undertaking it....

Our national American unconcern in the complicated entanglements of European politics gives us a peculiar clearness of vision and coolness of head wherewith to measure the chances and advantages of international alliances. We possess the double cosmopolitanism of the American and the Jew.... We have only to watch and wait and to put ourselves in readiness for action upon an emergency. 'The gods themselves,' says a Chinese proverb, 'cannot help him who loses opportunities.'

PART TWO

Her Vision

THE VALLEY OF BACA

PSALM LXXXIV

A brackish lake is there with bitter pools
 Anigh its margin, brushed by heavy trees.
A piping wind the narrow valley cools,
 Fretting the willows and the cypresses.
Gray skies above, and in the gloomy space
An awful presence hath its dwelling-place.

I saw a youth pass down that vale of tears;
 His head was circled with a crown of thorn,
His form was bowed as by the weight of years,
 His wayworn feet by stones were cut and torn.
His eyes were such as have beheld the sword
Of terror of the angel of the Lord.

He passed, and clouds and shadows and thick haze
 Fell and encompassed him. I might not see
What hand upheld him in those dismal ways,
 Wherethrough he staggered with his misery.
The creeping mists that trooped and spread around,
The smitten head and writhing form enwound.

Then slow and gradual but sure they rose,
 Those clinging vapors blotting out the sky.
The youth had fallen not, his viewless foes
 Discomfited, had left the victory
Unto the heart that fainted not nor failed,
But from the hill-tops its salvation hailed.

I looked at him in dread lest I should see,
 The anguish of the struggle in his eyes;
And lo, great peace was there! Triumphantly
 The sunshine crowned him from the sacred skies.
'From strength to strength he goes,' he leaves beneath
The valley of the shadow and of death.

'Thrice blest who passing through that vale of Tears,
 Makes it a well,' – and draws life-nourishment
From those death-bitter drops. No grief, no fears
 Assail him further, he may scorn the event.
For naught hath power to swerve the steadfast soul
Within that valley broken and made whole.

From *By the Waters of Babylon*

THE PROPHET

1. Moses Ben Maimon lifting his perpetual lamp over the path of the perplexed;

2. Hallevi, the honey-tongued poet, wakening amid the silent ruins of Zion the sleeping lyre of David;

3. Moses, the wise son of Mendel, who made the Ghetto illustrious;

4. Abarbanel, the counselor of kings; Alcharisi, the exquisite singer; Ibn Ezra, the perfect old man; Gabirol, the tragic seer; [20]

5. Heine, the enchanted magician, the heart-broken jester;

6. Yea, and the century-crowned patriarch whose bounty engirdles the globe; –

7. These need no wreath and no trumpet; like perennial asphodel blossoms, their fame, their glory resounds like the brazen-throated cornet.

8. But thou – hast thou faith in the fortune of Israel? Wouldst thou lighten the anguish of Jacob?

9. Then shalt thou take the hand of yonder caftaned wretch with flowing curls and gold-pierced ears;

10. Who crawls blinking forth from the loathsome recesses of the Jewry;

11. Nerveless his fingers, puny his frame; haunted by the batlike phantoms of superstition is his brain.

12. Thou shalt say to the bigot, 'My Brother,' and to the creature of darkness, 'My Friend.'

13. And thy heart shall spend itself in fountains of love

upon the ignorant, the coarse, and the abject.

14. Then in the obscurity thou shalt hear a rush of wings, thine eyes shall be bitten with pungent smoke.

15. And close against thy quivering lips shall be pressed the live coal wherewith the Seraphim brand the Prophets.

From *By the Waters of Babylon*

CHRYSALIS

1. Long, long has the Orient-Jew spun around his help-lessness the cunningly enmeshed web of Talmud and Kabbala.

2. Imprisoned in dark corners of misery and oppression, closely he drew about him the dust-gray filaments, soft as silk and stubborn as steel, until he lay death-stiffened in mummied seclusion.

3. And the world has named him an ugly worm, shunning the blessed daylight.

4. But when the emancipating springtide breathes wholesome, quickening airs, when the Sun of Love shines out with cordial fires, lo, the Soul of Israel bursts her cobweb sheath, and flies forth attired in the winged beauty of immortality.

Emma Lazarus

THE NEW EZEKIEL

What, can these dead bones live, whose sap is dried
 By twenty scorching centuries of wrong?
Is this the House of Israel, whose pride
 Is as a tale that's told, an ancient song?
Are these ignoble relics all that live
 Of psalmist, priest, and prophet? Can the breath
Of very heaven bid these bones revive,
 Open the graves and clothe the ribs of death?

Yea, Prophesy, the Lord hath said. Again
 Say to the wind, Come forth and breathe afresh,
Even that they may live upon these slain,
 And bone to bone shall leap, and flesh to flesh.
The Spirit is not dead, proclaim the word,
 Where lay dead bones, a host of armed men stand!
I ope your graves, my people, saith the Lord,
 And I shall place you living in your land.

From THE JEWISH PROBLEM

The melancholy and disgraceful fact being established that, in these closing decades of the nineteenth century, the long-suffering Jew is still universally exposed to injustice, proportioned to the barbarity of the nation that surrounds him, from the indescribable atrocities of Russian mobs, through every degree of refined insult to petty mortification, the inevitable result has been to arouse most thinking Jews to the necessity of a vigorous and concerted action of defense. They have long enough practiced to no purpose the doctrine which Christendom has been content to preach, and which was inculcated by one of their own race – when the right cheek was smitten to turn also the left. They have proved themselves willing and able to assimilate with whatever people and to endure every climatic influence. But blind intolerance and ignorance are now forcibly driving them into that position which they have so long hesitated to assume. *They must establish an independent nationality....*

From THE JEWISH PROBLEM

I am fully persuaded that all suggested solutions other than this are but temporary palliatives.... The idea formulated by George Eliot has already sunk into the minds of many Jewish enthusiasts, and it germinates with miraculous rapidity. 'The idea that I am possessed with,' says Deronda, 'is that of restoring a political existence to my people; making them a nation again, giving them a national centre, such as the English have, though they, too, are scattered over the face of the globe. That is a task which presents itself to me as a duty.... I am resolved to devote my life to it. *At the least, I may awaken a movement in other minds such as has been awakened in my own.*' Could the noble prophetess who wrote the above words have lived but till to-day to see the ever-increasing necessity of adopting her inspired counsel,... she would have been herself astonished at the flame enkindled by her seed of fire, and the practical shape which the movement projected by her in poetic vision is beginning to assume....

There is something absolutely startling in the world's sudden awakening to the probable destiny of Israel. To judge from the current literature of the day, as represented by the foremost European periodicals, it has been reserved for Christians to proclaim the speedy advent of that Jewish triumph for which the Jew has hoped against hope during his prolonged agony of twenty centuries.

THE BANNER OF THE JEW

Wake, Israel, wake! Recall to-day
 The glorious Maccabean rage,
The sire heroic, hoary-gray,
 His five-fold lion-lineage:
The Wise, the Elect, the Help-of-God,
The Burst-of-Spring, the Avenging Rod. [21]

From Mizpeh's mountain-ridge [22] they saw
 Jerusalem's empty streets, her shrine
Laid waste where Greeks profaned the Law,
 With idol and with pagan sign.
Mourners in tattered black were there,
With ashes sprinkled on their hair.

Then from the stony peak there rang
 A blast to ope the graves: down poured
The Maccabean clan, who sang
 Their battle-anthem to the Lord.
Five heroes lead, and following, see,
Ten thousand rush to victory!

Oh for Jerusalem's trumpet now,
 To blow a blast of shattering power,
To wake the sleepers high and low,
 And rouse them to the urgent hour!
No hand for vengeance – but to save,
A million naked swords should wave.

Emma Lazarus

O deem not dead that martial fire,
 Say not the mystic flame is spent!
With Moses' law and David's lyre,
 Your ancient strength remains unbent.
Let but an Ezra [23] rise anew,
To lift the *Banner of the Jew!*

A rag, a mock at first – erelong,
 When men have bled and women wept,
To guard its precious folds from wrong,
 Even they who shrunk, even they who slept,
Shall leap to bless it, and to save.
Strike! for the brave revere the brave! [24]

From AN EPISTLE TO THE HEBREWS XV

My chief aim has been to contribute ... towards arousing that spirit of Jewish enthusiasm which might manifest itself (1st), in a return to the varied pursuits and broad system of physical and intellectual education adopted by our ancestors; (2d), in a more fraternal and practical movement towards alleviating the sufferings of oppressed Jews in countries less favoured than our own; (3d), in a closer and wider study of Hebrew literature and history, and finally, in a truer recognition of the large principles of religion, liberty and law upon which Judaism is founded, and which should draw into harmonious unity Jews of every shade of opinion. Even in free America, we have not yet succeeded everywhere and at all times in persuading the non-Jewish community to accept or reject us upon our personal merits, instead of condemning us as a race for the vices or follies of individual members. This species of injustice, from which we occasionally suffer, in common with some other races, is the inevitable consequence of our representing an unpopular minority in opposition to a dominant and numerically overwhelming majority.

Under these circumstances, I do not think the Jews of America are sufficiently impressed with the necessity of solidarity and concord among themselves. The indomitable independence of the Jewish mind, that has almost miraculously preserved the type throughout all historical vicissitudes, occasionally asserts its individualism at the expense of the general dignity or welfare of our race. Hence arise so many trivial discussions, petty squabbles over insignificant details, hair-splitting of doctrines which

bear no vital relationship to the cardinal principles of Judaism....

The truth is that every Jew has to crack for himself this hard nut of his peculiar position in a non-Jewish community. But until all the Jews of the world can enter into something like harmonious agreement as to the best method of protecting themselves and each other against internal and external evils, the problem will remain unsolved; a few isolated Jews may win distinction through character, talent or wealth, but the mass will continue to be exposed to that contempt and aversion which they do not seek by any united effort of their own to dispel....

The condition of the Jews all over the world must inevitably be affected by the condition of several millions of people holding the same religious tenets and springing from the same ancestral stock, however widely they may be separated by seas and continents. What shall be done for those unfortunate creatures who groan under the double tyranny of despotism and ignorance is a question beset with such complicated difficulties that no one may presume to expect a unanimous acceptance of his or her attempted solution of the problem. All that I wish most earnestly to implore from Jews of every variety of political and religious belief is, that they lay aside personal and superficial considerations and approach this subject in the grave spirit which it imperatively demands.... The Jew (I say it proudly rather than deprecatingly) is a born rebel. He is endowed with a shrewd, logical mind, in order that he may examine and protest; with a stout and fervent heart in order that the instinct of liberty may grow into a consuming passion, whereby, if need be, all other

impelling motives shall be swallowed up. Such a one reluctantly submits to the restraint of discipline, even if it be imposed by the exigencies of his peculiar lot, in the interests of his own race. He may be charitable, generous, humane, sympathetic, but he has little genius for co-operation, and the whole history of Judaism shows that he cannot be led or coaxed or goaded into a herdlike obedience to authority. I do not forget the prevalent theory which contradicts my own, and maintains that Jews always form a close corporation, financially, socially and politically. But I do not think this general belief is corroborated by facts. Jews form a comparatively compact and homogeneous body when subjected to external pressure; but during intervals of freedom and expansion, it is notorious that they develop opinions in exact proportion to the number of individuals. Thus no settled policy for the general welfare of the united people is ever agreed upon, much less carried out....

To unite in concerted action a people so jealous of their individual privileges, is a task of such difficulty as to be generally deemed impossible. The lesson of discipline and organization is the last one that the Jews will learn; but until they have mastered it, they cannot hope to secure, by desultory, independent and often mutually conflicting efforts, equal conditions and human rights for their oppressed brethren.

THE NEW YEAR

Rosh-Hashanah, 5643 (1882)

Not while the snow-shroud round dead earth is rolled,
 And naked branches point to frozen skies, –
When orchards burn their lamps of fiery gold,
 The grape glows like a jewel, and the corn
A sea of beauty and abundance lies,
 Then the new year is born.

Look where the mother of the months uplifts
 In the green clearness of the unsunned West,
Her ivory horn of plenty, dropping gifts,
 Cool, harvest-feeding dews, fine-winnowed light;
Tired labor with fruition, joy and rest
 Profusely to requite.

Blow, Israel, the sacred cornet! Call
 Back to thy courts whatever faint heart throb
With thine ancestral blood, thy need craves all.
 The red, dark year is dead, the year just born
Leads on from anguish wrought by priest and mob,
 To what undreamed-of morn?

For never yet, since on the holy height,
 The Temple's marble walls of white and green
Carved like the sea-waves, fell, and the world's light
 Went out in darkness, – never was the year
Greater with portent and with promise seen,
 Than this eve now and here.

Even as the Prophet promised, so your tent
 Hath been enlarged unto earth's farthest rim.
To snow-capped Sierras from vast steppes ye went,
 Through fire and blood and tempest-tossing wave,
For freedom to proclaim and worship Him,
 Mighty to slay and save.

High above flood and fire ye held the scroll,
 Out of the depths ye published still the Word.
No bodily pang had power to swerve your soul:
 Ye, in a cynic age of crumbling faiths,
Lived to bear witness to the living Lord,
 Or died a thousand deaths.

In two divided streams the exiles part,
 One rolling homeward to its ancient source,
One rushing sunward with fresh will, new heart.
 By each the truth is spread, the law unfurled,
Each separate soul contains the nation's force,
 And both embrace the world.

Kindle the silver candle's seven rays,
 Offer the first fruits of the clustered bowers,
The garnered spoil of bees. With prayer and praise
 Rejoice that once more tried, once more we prove
How strength of supreme suffering still is ours
 For Truth and Law and Love.

Emma Lazarus

From AN EPISTLE TO THE HEBREWS VIII

The fact that the Jews of America are civilly and religiously emancipated should be, I take it, our strongest impelling motive for working towards the emancipation of our oppressed brethren. No other Jews in the world can bring to bear upon the enterprise such absolute disinterestedness of aim, such long and intimate familiarity with the blessings and delights of liberty. We must help our less fortunate brethren, not with the condescending patronage of the prosperous, who in self-defence undertake to conceal the social sores of the community by providing a remote hiding-place for the outcast and the beggar, but with the keen, human sympathy of men and women who endeavor to defend men and women against outrage and oppression, of Jews who feel the sting of every wound and insult inflicted upon their blood-kindred.... By virtue of our racial and religious connection with these helpless victims of anti-Jewish cruelty, we feel that it devolves upon us to exert our utmost strength towards securing for them permanent protection.

It has become evident to a large majority of Jews that such permanent protection can never be afforded while masses of our people are concentrated in certain districts of Europe amidst hostile, or at the least unfriendly, nations; where their free intellectual development is checked by legislative and social disabilities, and where at any moment an outbreak of popular fanaticism or the contagion of illiberal opinions may imperil their very existence....

For the Christian share in all this shiftless misery, there

was of course no excuse. For our own share, the only excuse was, that we were utterly unprepared for the emergency. Yes, despite the horrors of the Inquisition, the anguish of the Middle Ages, the thinly-veneered barbarism of certain European countries in our own day, we were *not* prepared to find ourselves suddenly swept back into the full current of mediaeval principles. On the eve of the twentieth century, we had not taken measures to guard even our weakest outposts against a revival of those social, or rather anti-social forces which we fancied had been exterminated by the French and American Revolutions. But the scales have fallen from our eyes, and we can no longer remain blind to the fact that all the boasted civilization of nineteen Christian centuries is not sufficient to protect us in the old world against a periodical recurrence of this disgraceful reaction....

Re-nationalization, Auto-Emancipation, repatriation – call it by what name you will, the same solution of the problem is suggested by friend and foe alike. Both echo with one voice the opinion that a numerous, highly vitalized people, who (whether for sound or unsound reasons) are obnoxious to the nation among whom they reside, have nothing to do but to create a home of their own, and relieve offended society of their unwelcome presence.... Only by establishing them independently in a territory of their own could they enter upon a free, secure and dignified existence. The emancipated Jews of the whole world should unite in promoting this end, indispensable to the moral and material salvation of our race....

That the united wealth of Judaism would be more than equal to this demand upon it, there can be no question; nor can it he doubtful that the moral and intellectual

influence of Judaism, if brought to bear upon the govern-
ments and peoples of the world to urge them to counte-
nance our enterprise, would be immense, if not
irresistible. But before the first step can be taken, we must
have *union* and *organization*. We must see clearly that the
welfare of humanity and the dignity of our race demand
from us a mighty effort in behalf of others, however
secure and prosperous be our own individual lot as
American citizens.

THE FEAST OF LIGHTS
(Chanukah)

Kindle the taper like the steadfast star
　　Ablaze on evening's forehead o'er the earth,
And add each night a lustre till afar
　　An eightfold splendor shine above thy hearth.
Clash, Israel, the cymbals, touch the lyre,
　　Blow the brass trumpet and the harsh-tongued horn;
Chant psalms of victory till the heart take fire,
　　The Maccabean spirit leap new-born.

Remember how from wintry dawn till night,
　　Such songs were sung in Zion, when again
On the high altar flamed the sacred light,
　　And, purified from every Syrian stain,
The foam-white walls with golden shields were hung,
　　With crowns and silken spoils, and at the shrine,
Stood, midst their conqueror-tribe, five chieftains sprung
　　From one heroic stock, one seed divine.

Five branches grown from Mattathias' stem,
　　The Blessed John, the Keen-Eyed Jonathan,
Simon, the fair, the Burst-of-Spring, the Gem,
　　Eleazar, Help-of-God; o'er all his clan
Judas the Lion-Prince, the Avenging Rod,
　　Towered in warrior-beauty, uncrowned king,
Armed with the breastplate and the sword of Good,
　　Whose praise is: 'He received the perishing.'

Emma Lazarus

They who had camped within the mountain-pass,
 Couched on the rock, and tented neath the sky,
Who saw from Mizpah's heights the tangled grass
 Choke the wide Temple-courts, the altar lie
Disfigured and polluted – who had flung
 Their faces on the stones, and mourned aloud
And rent their garments, wailing with one tongue,
 Crushed as a wind-swept bed of reeds is bowed,

Even they by one voice fired, one heart of flame,
 Though broken reeds, had risen, and were men,
They rushed upon the spoiler and o'ercame,
 Each arm for freedom had the strength of ten.
Now is their mourning into dancing turned,
 Their sackcloth doffed for garments of delight,
Week-long the festive torches shall be burned,
 Music and revelry wed day with night.

Still ours the dance, the feast, the glorious Psalm,
 The mystic lights of emblem, and the Word.
Where is our Judas? Where our five-branched palm?
 Where are the lion-warriors of the Lord?

Clash, Israel, the cymbals, touch the lyre,
 Sound the brass trumpet and the harsh-tongued horn,
Chant hymns of victory till the heart take fire,
 The Maccabean spirit leap new-born!

From *An Epistle to the Hebrews* [27]

INTRODUCTORY

It is a singular fact that the contemporary student of Jewish life and character derives chiefly from Christian sources, a faith in the regenerating powers of Judaism. The Jews themselves, especially those of America, seem rarely imbued with that vivid sense of the possibilities and responsibilities of their race, which might result in such national action as to justify the expectations (and in some cases the ignoble fears) of their Gentile critics. When one turns glowing with enthusiasm from the pages of George Eliot, of Gabriel Charmes, of Ernest Havet, of Lawrence Oliphant, [28] to the actual Jewish community amidst which we live, one is half tempted to believe that it is necessary to be born outside of Judaism in order to appreciate the full beauty and grandeur of her past, the glory and infinite expansiveness of her future. The unworthy desire on the part of many Jews to conceal their lineage, evinced in the constant transmutation of family-names, and in the contemptible aversion and hostility manifested between Jews of varying descent, painfully prove the absence of both the spirit and the training essential to a higher national existence. Fancy a self-respecting American, Englishman, Frenchman, etc., endeavoring to impose upon his neighbors the idea that he belongs to a race other than his own! Yet nothing is more common (and we may add, more futile) among the Jews. As long as every man respects the virtues and achievements of his ancestors, he is proud to claim his rightful lineage. Only when a

deep and abiding sense of national humiliation has taken root, is it possible for men of ordinary honesty and intelligence to repudiate or shrink from acknowledgment of their descent. Nor have we in America the excuse for such national weakness as has been elsewhere afforded up to our own day by the brutal Jew-baiting of European countries. A century of civil and religious equality has removed every extenuating circumstance that could be pleaded for it.

From AN EPISTLE TO THE HEBREWS II

He who would faithfully serve the larger interests of humanity must learn in due order to become the valiant protector of his own hearth, his own kin, his own people, his own kind. Utterly false and groundless is the assumption that a strict allegiance to the spirit of Judaism, a thorough interpenetration with her historic memories and poetic traditions, need conflict in any way with the Jews' duties or sentiments as citizens of a non-Jewish State. On the contrary, an intensifying of the noblest Hebrew spirit would tend to make better citizens, inasmuch as it would surely make better men....

To combine the conservation of one's own individuality with a due respect for the rights of every other individuality, is the ideal condition of society, but it is a foolish perversion of this truth to deduce therefrom the obligation to renounce all individuality; and this remark is no less applicable to nations than to persons. Not by disclaiming our 'full heritage', but by lifting up our own race to the standard of morality and instruction shall we at the same time promote the advancement and elevation of the Gentiles. Teaching by example, not by proselytism, has ever been the method of Israel. But he can fulfil his high vocation only on condition of maintaining himself at that level of moral and intellectual eminence where he becomes a beacon-light to others. To carry out this exalted conception we require a nation of priests, that is to say of priests in the best and original sense of the word – devoted servants of the holy spirit. But if our people persist in entrenching themselves behind a Chinese wall of

petrified religious forms, the great modern stream of scientific philosophy will sweep past them, carrying Humanity to new heights, and will leave them far in the rear. The question is, where are we to look in America for the patriotic Jew whose intellect is sufficiently expanded to accept all the conclusions of science, and yet whose sense of the moral responsibilities and glories bequeathed to him by his ancestors is sufficiently vivid to kindle him into a missionary and a prophet?...

From AN EPISTLE TO THE HEBREWS VI

'It is always the impossible which happens,' said a witty Frenchman, and the axiom is applicable in a peculiar sense to the Jewish people. 'A Jew may be a prophet but cannot be a philosopher,' the world once fancied, and the Jews produced a Philo, a Maimonides, a Spinoza. After we had for centuries been excluded from political life, we were told that a Jew could not be a statesman. But the external barriers were removed, and within a single generation behold a Beaconsfield, a Lasker, a Gambetta. Plastic art is presumed to be especially obnoxious to the spirit of Judaism, therefore no Jew can be a sculptor. Yet one of the greatest living sculptors, a native of Russia, where Jews are still exposed to mob violence, is a Jew, M. Antokolski. And now, as if the greater did not include the less, we hear on all sides the cry, 'A Jew cannot be an agriculturist.' Read the reports of the colonies of refugees at Cotopaxi, Colorado, and Vineland, New Jersey, and you have facts and figures as a 'victorious declaration of the truth that the Hebrew can be a farmer and is a farmer.'... [29]

In other words, a race whose spiritual and intellectual influence upon the world has been universally accounted second to none, and whose physical constitution has adapted itself to the vicissitudes of every climate, *can be whatever they will be.* Yes, we need only 'help to will our own better future,' and that future shall accomplish itself as by miracle. But as we are at present situated, whatever faculty we acquire only redounds to our ultimate disadvantage, and I know a warm Jewish patriot who grieves

Emma Lazarus

whenever he hears of a mark of distinction won by a Jew. For as soon as we adopt a new method of earning an honest livelihood, such skill as we happen to develop at it only brings down upon us from unsuccessful competitors of other races the old charges of monopolizing and of mysterious tribal collusion. The persecution of the Russian Jews and the Anti-Semitic anachronisms of Germany have smitten a people widely different from that passive race, whose only shield from mediaeval cruelty was patient sufferance.... Once let the popular will find expression in a united resolve, and the impulse towards new national life will be irresistible.

From AN EPISTLE TO THE HEBREWS VII

Every advocate of the repatriation of the Jewish people is met at the outset with the apparently insuperable objection: 'The Jews themselves do not desire it.'...

Who will say, in face of the unexampled history of the Jewish people, that they are as a race less easily swayed by the enthusiasm of principles, less easily kindled by an appeal to their imagination, less able and willing to endure the privations and sufferings entailed by championing a desperate cause, than any other race in the world?

What but an Idea, a high spiritual aim, impelled last year the Russian and Polish refugees to exile themselves in myriads from the land where they and their ancestors had been born and bred, and whose very language was unknown in the countries where they sought shelter?...

Among the thousands who emigrated were hundreds of students, intelligent youths or ripened scholars, upon whom Judaism as a religion had lost all hold, but whose hearts beat none the less loyally for the race and its glorious traditions. From such men as these, capable and trained to adorn the ranks of any liberal profession, were picked the labourers and tillers of the soil, who form the nuclei of the present agricultural colonies. Would it not be difficult to find to-day among many races patriots so enthusiastic as to offer such sacrifices as these for the sake of a nation without a fatherland? These Russian-Jewish emigrants bear living witness to the fact that the spirit of martyrs and heroes is not extinct among our people; that these same people are capable of comprehending the

principle of consolidation and desiring a restoration, we have the testimony of an outside observer who has made a broad and close personal investigation of the subject – Mr Oliphant. 'The idea of a return to the East has seized upon the imagination of the masses and produced a wave of enthusiasm in favor of emigration to Palestine, the force and extent of which only those who have come in direct contact with it, as I have done, can appreciate.'

From AN EPISTLE TO THE HEBREWS XI

Let us now examine ... in what spirit the Jews met and observed the day of rest. The Hebrews were not originally a sad people; civic banquets, mirth and music formed part of their worship. Nearly all their older festivals have a gay and joyous character, and 'are connected with the celebration of the blessings of the earth and the power that fertilizes it, or with liberty and law which give life to agriculture as well as to Man himself.' It has only been during centuries of persecution that fast-days, periods of mourning, contrition and sorrow have multiplied in the Hebrew calendar.... The Sabbath, or religious day, is invariably spoken of throughout the Ritual as a day of rejoicing, no less than of rest. Oriental imagery exhausts itself in metaphors of beauty, joy and honor wherewith to adorn it. 'Come, my love, to meet the bride, the presence of the Sabbath let us receive.'...

Among the duties of the Sabbath, we are enjoined 'to taste three meals, to include psalm, song and praise in our ceremonies, to remove mourning and weeping far from the Sabbath, to observe the sanctified delight of the Sabbath.'

With the breaking of the first star in the heavens the seven-branched candlestick is lighted, and the song of gladness is intoned....

Our Sabbath is dedicated at the same time to patriotism, to humanity, to religion and to joy. For with the Jews there is no sharp dividing-line between the ethics of this world and the affairs of the next; patriotism and religion are so blended as to be practically inseparable. On this

day, therefore, a Jew belongs peculiarly to his people and his kind as well as to his God; on six other days he may labor for himself. It is thus pre-eminently a festal day of gladness and merry-making, and every word of the Bible and the Ritual relating to it proves such to have been its spirit.

From JUDAISM:
THE CONNECTING LINK BETWEEN SCIENCE
AND RELIGION [30]

The Christian Church, as Professor Seeley says, is based upon Judaism; all that it has added to Judaism is not liberty, equality or fraternity, for they were already incorporated in the Hebrew law, but the doctrines of the Trinity, Resurrection, supernaturalism and asceticism. By renouncing these, it becomes once more Judaism, and if Professor Seeley wishes to see established and organized the 'natural Christianity' for which he longs, he has only to enter the synagogue.

'Time, change and development' are in fact the subject matter of Judaism. The gradual elevation and refinement of the Hebrew conception of God from anthropomorphism to pure spiritualism proves how it may adapt itself without danger to the progress of human thought. It is not, like every other religion, hampered by mythology or legend. The idea of the unity of the creative force and the necessity of the moral law – these are its sacred treasures, acquired by the wisdom of the forefathers, and neither assailed nor reached by all the revolutions of modern science. All that Christianity has superimposed upon this basis has crumbled or is crumbling to ruins; but this faith, capable of infinite expansion and subtilization, may go hand in hand with science, strong and steadfast as herself, to the very brink of the unknowable and the unthinkable.

From AN EPISTLE TO THE HEBREWS X

It has already been pointed out by a Christian writer, that 'the legislation of Moses admitted of a provision for the organic growth of the human intellect. The men who attributed to every word and to every letter of the Pentateuch a direct and divine origin and ordination, yet admitted a maxim inspired by the profoundest common-sense, the application of which would have prevented the shameful struggle of the Holy See with the immortal Galileo. 'The Law speaks in the language of the sons of men.' The highest human study, the Rabbins taught, was that of the Law. But if positive science in other hands made definite discoveries, there was an elasticity in the unchangeable word that could never permit of any contradiction arising between Faith and Science....'

Christian voices to-day are not lacking to attest that the longed-for reconciliation between Science and Religion can only be effected by means of a return to Judaic principles – pure Monotheism, the reign of law and historic development. The harmony existing between sublimated Judaism and scientific philosophy was brought vividly before me lately by reading in immediate succession two books representing widely-divergent periods of civilization and phases of thought – the *First Principles* of Herbert Spencer, and the *Guide to the Perplexed* of Moses Maimonides. In the latter's spiritual and religious speculations and in his interpretation of the Bible, I found no single idea that conflicted with the thoughts put forward by the most eminent living English philosopher concerning the Ultimate Religious Beliefs of Man....

The religion of Reason and of Law inculcates but one mystery – the unity of the creative force, and leaves the vexed question of personal immortality to be decided according to the ineffable experience of every individual soul. Not in the past, but in the future, it places the Messianic age of peace, prosperity and universal brotherhood.

From M. RENAN AND THE JEWS [31]

In the prophetic books are laid down, on broad bases, the foundations of a universal religion, a religion that preaches the purest, spiritual monotheism, the abolition of sacrifices and ritualism, the necessity of the moral law, the brotherhood of man, and the ultimate reign of peace and justice. Such, indeed, is the conclusion to which Christian scholars arrive. M. Renan continues: 'The pure religion which we foresee, that will prove capable of rallying all humanity to its standard, will be the realization of the religion of Isaiah, *the ideal Jewish religion,* purged of the dross that may have been mixed with it. Let us say it boldly, Judaism which has done such service in the past will serve also in the future. It will serve the true cause, the cause of liberalism and of the modern spirit.'

Such words as these send a thrill of exultation through the veins of every true Jew; not the unworthy pride of a flattered egotism, but the glorious sense of an inconceivably noble vocation. Nothing less than the universal welfare, bought at this price, could compensate the Hebrew race for having served through history as the type of suffering. Not for the mere survival of this little band of martyrs and victims was the miracle of their endurance prolonged; but because the seed of truth, which they alone cherished through fire and blood, had not yet borne its highest, sweetest and ripest fruit.

From THE JEWISH PROBLEM

It is assumed by Christian historians that the Jews, with their inflexible adherence to the Mosaic Code, are, as a people, a curious relic of remote antiquity, a social anachronism, so to speak, petrified in the midst of advancing civilization. This assumption is without foundation; the Jews are, on the contrary, most frequently the pioneers of progress. The simplicity of their creed enables them more readily and naturally to throw off the shackles of superstition and to enlarge the boundaries of free speculation than any other sect. Considering their religion from the highest standpoint, their creed to-day is at one with the latest doctrines of science, proclaiming the unity of the Creative force. No angels, saints, or mediators have any place in this sublime conception, arrived at intuitively in a pre-historic age by the genius of the race, and confirmed by that modern scientific research which has revolutionized the thought of the world. The modern theory of socialism and humanitarianism, erroneously traced to the New Testament, has its root in the Mosaic Code....

The very latest reforms urged by political economists, in view of the misery of the lower classes, are established by the Mosaic Code, which formulated the principle of the rights of labor, denying the right of private property in land, asserting that the corners of the field, the gleanings of the harvest belonged in *justice*, not in *charity*, to the poor and the stranger; and that man owed a duty, not only to all humanity, but even to the beast of the field, and 'the ox that treads the corn'.

In accordance with these principles, we find the fathers of modern socialism to be three Jews — Ferdinand Lassalle, Karl Marx, and Johann Jacoby.... [32]

Patriot of Freedom

From
ON THE PROPOSAL TO ERECT A MONUMENT
IN ENGLAND TO LORD BYRON

Fair was the Easter Sabbath morn when first
 Men heard he had not wakened to its light:
The end had come, and time had done its worst,
 For the black cloud had fallen of endless night.
Then in the town, as Greek accosted Greek,
'T was not the wonted festal words to speak,
'Christ is arisen,' but 'Our chief is gone,'
 With such wan aspect and grief-smitten head
 As when the awful cry of 'Pan is dead!'
Filled echoing hill and valley with its moan.

'I am more fit for death than the world deems,'
 So spake he as life's light was growing dim,
And turned to sleep as unto soothing dreams.
 What terrors could its darkness hold for him,
Familiar with all anguish, but with fear
Still unacquainted? On his martial bier
They laid a sword, a helmet, and a crown –
 Meed of the warrior, but not these among
 His voiceless lyre, whose silent chords unstrung
Shall wait – how long? – for touches like his own.

An alien country mourned him as her son,
 And hailed him hero: his sole, fitting tomb
Were Theseus' temple or the Parthenon,
 Fondly she deemed. His brethren bare him home,
Their exiled glory, past the guarded gate

Where England's Abbey shelters England's great.
Afar he rests whose very name hath shed
 New lustre on her with the song he sings.
 So Shakespeare rests who scorned to lie with kings,
Sleeping at peace midst the unhonored dead....

The years' thick, clinging curtains backward pull,
 And show him as he is, crowned with bright beams,
'Beauteous, and yet not all as beautiful
 As he hath been or might be; Sorrow seems
Half of his immortality.' [32] He needs
No monument whose name and song and deeds
Are graven in all foreign hearts; but she
 His mother, England, slow and last to wake,
 Needs raise the votive shaft for her fame's sake:
Hers is the shame if such forgotten be!

 May 1875

From HOW LONG?

How long, and yet how long,
Our leaders will we hail from over seas,
Masters and kings from feudal monarchies,
 And mock their ancient song
With echoes weak of foreign melodies?

 That distant isle mist-wreathed,
Mantled in unimaginable green,
Too long hath been our mistress and our queen.
 Our fathers have bequeathed
Too deep a love for her, our hearts within.

 She made the whole world ring
With the brave exploits of her children strong,
And with the matchless music of her song.
 Too late, too late we cling
To alien legends, and their strains prolong.

 This fresh young world I see,
With heroes, cities, legends of her own;
With a new race of men, and overblown
 By winds from sea to sea,
Decked with the majesty of every zone....

Emma Lazarus

From *SIC SEMPER LIBERATORIBUS*

13 MARCH 1881

So the White Czar imperial progress made
Through terror-haunted days. A shock, a cry
Whose echoes ring the globe – the spectre's laid.
Hurled o'er the abyss, see the crowned martyr lie
Resting in peace – fear, change, and death gone by.
Fit end for nightmare – mist of blood and tears,
Red climax to the slow, abortive years....

Well, it is done! A most heroic plan,
Which after myriad plots succeeds at last
In robbing of his life one poor old man,
Whose sole offence – his birthright – has but passed
To fresher blood, with younger strength recast.
What men are these, who, clamoring to be free,
Would bestialize the world to what they be?

Whose sons are they who made that snow-wreathed head
Their frenzy's target? In their Russian veins,
What alien current urged on to smite him dead
Whose sword had loosed a million Russian chains?
What brutes were they for whom such speechless pains,
So royally endured, no human thrill
Awoke, in hearts drunk with the lust to kill?

Not brutes! No tiger of the wilderness,
No jackal of the jungle, bears such brand
As man's black heart, who shrinks not to confess
The desperate deed of his deliberate hand.
Our kind, our kin, have done this thing. We stand
Bowed earthward, red with shame, to see such wrong
Prorogue Love's cause and Truth's – God knows how
 long!

SUNRISE

26 September 1881

Weep for the martyr! Strew his bier
With the last roses of the year;
Shadow the land with sables; knell
The harsh-tongued, melancholy bell;
Beat the dull muffled drum, and flaunt
The drooping banner; let the chant
Of the deep-throated organ sob –
One voice, one sorrow, one heart-throb,
From land to land, from sea to sea –
The huge world quires his elegy.
Tears, love, and honor he shall have,
Through ages keeping green his grave.
Too late approved, too early lost,
His story is the people's boast.
Tough-sinewed offspring of the soil,
Of peasant lineage, reared to toil,
In Europe he had been a thing
To the glebe tethered – here a king!
Crowned not for some transcendent gift,
Genius of power that may lift
A Caesar or a Bonaparte
Up to the starred goal of his heart;
But that he was the epitome
Of all the people aim to be.
Were they his dying trust? He was
No less their model and their glass.
In him the daily traits were viewed

Of the undistinguished multitude.
Brave as the silent myriads are,
Crushed by the juggernaut world-car;
Strong with the people's strength, yet mild,
Simple and tender as a child;
Wise with the wisdom of the heart,
Able in council, field, and mart;
Nor lacking in the lambent gleam,
The great soul's final stamp – the beam
Of genial fun, the humor sane
Wherewith the hero sports with pain.
His virtues hold within the span
Of his obscurest fellow-man.
To live without reproach, to die
Without a fear – in these words lie
His highest aims, for none too high.
No triumph his beyond the reach
Of patient courage, kindly speech;
And yet so brave the soul outbreathed,
The great example he bequeathed,
Were all to follow, we should see
A universal chivalry.

His trust, the People! They respond
From Maine to Florida, beyond
The sea-walled continent's broad scope,
Honor his pledge, confirm his hope.
Hark! over seas the echo hence,
The nations do him reverence.
An Empress lays her votive wreath
Where peoples weep with bated breath.
The world-clock strikes a fateful hour,

Bright with fair portents, big with power, –
The first since history's course has run,
When kings' and peoples' cause is one;
Those mourn a brother – these a son!

O how he loved them! That gray morn,
When his wound-wasted form was borne
North, from the White House to the sea,
Lifting his tired lids thankfully,
'How good,' he murmured in his pain,
'To see the people once again!'
Oh, how they loved him! They stood there,
Thronging the road, the street, the square,
With hushed lips locked in silent prayer,
Uncovered heads and streaming eyes,
Breathless as when a father dies.
The records of that ghostly ride,
Past town and field at morning-tide.

When life's full stream is wont to gush
Through all its ways with boisterous rush,
– The records note that once a hound
Had barked, and once was heard the sound
Of cart-wheels rumbling on the stones –
And once, mid stifled sobs and groans,
One man dared audibly lament,
And cried, 'God bless the President!'
Always the waiting crowds to send
A God-speed to his journey's end –
The anxious whisper, brow of gloom,
As in a sickness-sacred room,

Till his ear drank with ecstasy
The rhythmic thunders of the sea

Tears for the smitten fatherless,
The wife's, the mother's life-distress,
To whom the million-throated moan
From throne and hut, may not atone
For one hushed voice, one empty chair,
One presence missing everywhere.
But only words of joy and cheer,
The people from his grave shall hear.
Were they not worthy of his trust,
From whose seed sprang the sacred dust?
He broke the bars that separate
The humble from the high estate.
And heirs of empire round his bed
Mourn with the 'disinherited.'

Oh, toll-worn, patient Heart that bleeds,
Whose martyrdom even his exceeds,
Wronged, cursed, despised, misunderstood –
Oh, all-enduring multitude,
Rejoice! amid your tears, rejoice!
There issues from this grave a voice,
Proclaiming your long night is o'er,
Your day-dawn breaks from shore to shore.
You have redeemed his pledge, remained
Secure, erect, and self-sustained,
Holding more dear one thing alone,
Even than the blood of dearest son,
Revering with religious awe
The inviolable might of Law.

From
A DAY IN SURREY WITH WILLIAM MORRIS [33]

Mr Morris's extreme socialistic convictions are the sub-
ject of so much criticism at home, that a few words con-
cerning them may not be amiss here. Rather would he see
the whole framework of society shattered than a continu-
ance of the actual condition of the poor. 'I do not want
art for a few, any more than education for a few or free-
dom for a few. No, rather than that art should live this
poor, thin life among a few exceptional men, despising
those beneath them for an ignorance for which they them-
selves are responsible, for a brutality which they will not
struggle with; rather than this, I would that the world
should indeed *sweep away all art for a while....* Rather
than the wheat should rot in the miser's granary, I would
that the earth had it, that it might yet have a chance to
quicken in the dark.'

The above paragraph from a lecture delivered by Mr
Morris before the Trades' Guild of Learning, gives the key
to his socialistic creed, which he now makes it the main
business of his life to promulgate. In America the avenues
to ease and competency are so broad and numerous, the
need for higher culture, finer taste, more solidly con-
structed social bases is so much more conspicuous than
the inequality of conditions, and the necessity to level and
destroy, that the intelligent American is apt to shrink with
aversion and mistrust from the communistic enthusiast.
In England, however, the inequalities are necessarily more
glaring, the pressure of that densely crowded population
upon the means of subsistence is so strenuous and

painful, that the humane on-looker, whatever be his own condition, is liable to be carried away by excess of sympathy. One hears to-day of individual Englishmen of every rank flinging themselves with reckless heroism into the breach, sacrificing all thought of personal interest in the desperate endeavor to stem the huge flood of misery and pauperism. Among such men stands William Morris, and however wild and visionary his hopes and aspirations for the people may appear to outsiders, his magnanimity must command respect. No thwarted ambitions, no stunted capacities, no narrow, sordid aims have ranged him on the side of the disaffected, the agitator, the outcast. As poet, scholar, householder, and capitalist, he has everything to lose by the victory of that cause to which he has subordinated his whole life and genius.

LETTER TO HENRY GEORGE

New York
34 East 57th Street

17 October 1881

My Dear Mr George –

Pray accept my warmest thanks for your extremely kind
note & for the eloquent pamphlet which I had already
read & deeply appreciated, but which I need scarcely say
will have a priceless additional value for me as coming
from your own hands. I regretted more than I can say, the
loss of your promised visit, & indeed, I curtailed my stay
in the country in order not to miss the possible chance of
seeing you –. To my great disappointment I saw by the
papers that you had already sailed on the day of my
return. The receipt of your generous note was therefore a
pleasure as unexpected as it was gratifying.

I wish I could convey to you an idea of the feelings
aroused in me by your book. No thinking man or woman
in these days can have remained altogether deaf to that
mute 'appeal which once heard can never be forgotten';
but the same appeal when interpreted by your burning
eloquence, takes possession of one's mind & heart to
such a degree as overpowers all other voices – Your work
is not so much a book as an event – the life & thought of
no one capable of understanding it can be quite the same
after reading it, – & even in the small circle of my person-
al friends I have had abundant evidence of the manner in

which it sets the minds of men on fire – 'all men capable of feeling the inspiration of a great principle.' And how should it be otherwise? For once prove the indisputable truth of your idea, & no person who prizes justice or common honesty can dine or sleep or read or work in peace until the monstrous wrong in which we are all accomplices be done away with – I congratulate you most heartily on the natural gifts with which you have been endowed for the noble cause you have espoused – Great as is the idea, it would certainly fail to kindle men's minds as it does now, if pleaded with less passionate eloquence, less authoritative knowledge.

I am glad to hear that your stay abroad is to be a short one, for I shall allow myself the pleasure of looking forward confidently to the hope of seeing you on your return. We have many mutual friends besides Mr Lindau, all of whom have talked to me of you with the same enthusiasm – But I am proud to think that I need not rely upon any one else to bring us together. We have spoken with each other & know each other's voices, & at the end of six months or of six years, if I were still here, I should be no less sure of your sympathy & friendly remembrance. Meantime with earnest wishes for yourself & your cause, believe me

Gratefully & sincerely yours,

Emma Lazarus

Henry George, Esquire

Emma Lazarus

PROGRESS AND POVERTY [34]

(After Reading Mr Henry George's Book)

Oh splendid age when Science lights her lamp
At the brief lightning's momentary flame,
Fixing it steadfast as a star, man's name
Upon the very brow of heaven to stamp!
Launched on a ship whose iron-cuirassed sides
Mock storm and wave, Humanity sails free;
Gayly upon a vast, untraveled sea
O'er pathless wastes, to ports undreamed she rides,
Richer than Cleopatra's barge of gold,
This vessel, manned by demi-gods, with freight
Of priceless marvels. But where yawns the hold
In that deep, reeking hell, what slaves be they,
Who feed the ravenous monster, pant and sweat,
Nor know if overhead reign night or day?

Notes

Introduction

[1] *Minyan: Ten Jewish Lives in Twenty Centuries of History*, by Chaim Raphael, Pangloss Press, Malibu, 1992.

[2] The other women were Dona Gracia Nasi in the 16th century and Glueckel of Hamlyn in the 17th and 18th centuries.

[3] *Torch Songs: The Poetry, Politics and Identity of Emma Lazarus*, by Anne Janowitz, *Jewish Quarterly*, Spring 1996.

[4] 'Josephine Lazarus', introductory essay in *The Poems of Emma Lazarus*, Houghton Mifflin, Boston, 1895.

[5] *Emma Lazarus in her World: Life and Letters*, Bette Roth Young, The Jewish Publication Society, Philadelphia and Jerusalem, 1995. This includes letters to two close friends, Helena deKay Gilder, wife of Richard Gilder, the editor of *The Century*, and Rose Hawthorne Lathrop, daughter of Nathaniel Hawthorne.

[6] Charles deKay, brother of Helena. Young, *op. cit.*

[7] Joseph Gilder, editor of *The Critic*, cited in foreward by Francine Klagsbrun to Young, *op. cit.*

[8] This information has been derived from Young, *op. cit.* and *Mixed Blessings*, Paul Cowan and Rachel Cowan, Doubleday, New York, 1987.

[9] Josephine Lazarus, introductory essay, *op. cit.*

[10] Letter to Rose Hawthorne Lathrop, Young, *op. cit.*, p. 192.

[11] Letter to Helena deKay Gilder, Young. *op. cit.*, p. 122.

[12] Apparently Emma kept Eliot's photograph on her desk and introduced it to visitors as 'Marian'. Janowitz, *op. cit.*, quoting from Heinrich E. Jacob, *The World of Emma Lazarus*, New York, 1949. However, Jacob is not thought of as too reliable a source by many commentators.

[13] Eastern Jews. *Ostjuden* were traditionally scorned by so-called 'civilised' western Jews.

[14] Francine Klagsbrun, foreward to Young, *op. cit.*

[15] *Ibid.*

[16] Young, *op. cit.*

[17] *Ibid.*

[18] *Ibid.*

[19] *Ibid.*

[20] *An Epistle to the Hebrews*, Epistle 14.

[21] Young, *op. cit.*
Lazarus was criticised for advocating industrial and physical labour above all else in a letter to *The American Hebrew* of 1 December 1882.

[22] Bernard Richards, an American editor, wanted to include Lazarus' Jewish poetry in a series that would contain the Jewish writings of Georges Clémenceau, Stefan Zweig and Georg Brandes, a Danish literary critic who had promoted Nietzche (information from Cowan, *op. cit.*).

[23] Information about this episode from Cowan, *op. cit.*, and Young, *op. cit.*

[24] Constance Harrison, a descendant of Thomas Jefferson, cited in Cowan, *op. cit.*

[25] Cowan, *op. cit.*

[26] Letter to Rose Hawthorne Lathrop, Young, *op. cit.*, p. 193.

[27] One of the men was Edwin Robert Anderson Seligman, the son of Joseph Seligman.

[28] Based on the great biblical commentator, Rashi.

[29] In his autobiography, *All Rivers run to the Sea*, Elie Wiesel writes that he felt 'intimately bound to the Jews of the Middle Ages who wore the *rouelle*'.

[30] The failure of the Jews to heed Rabbi Cresselin's warning also foreshadowed similar occurrences at the time of the Holocaust. Wiesel tells of Moshe the beadle who escaped from an early Nazi action in which his family had been slaughtered and was considered mad by his fellow townsmen when he warned them of the fate that awaited them. Also the Polish resistance fighter, Jan Karski, who had witnessed scenes in the Warsaw Ghetto and in an early death camp, tried to alert the American Supreme Court judge, Felix Frankfurter, to what was happening to the Jews of Europe but was simply not believed.
The dignity of the Jews as they prepare for their fate in Lazarus' drama is echoed, once again, in Wiesel: 'Throughout the ordeal they maintained their dignity as human beings and as Jews.... Against the enemy they stood as one, affirming their faith in their faith.'

[31] *Sunrise*, composed, as I learned from Professor Schappes, two days after the Jewish New Year, has a curious finale in which

Lazarus, the American patriot, seems to be proclaiming her Jewish credentials.

[32] Anna Laurens Dawes, cited in Young, *op. cit.*

[33] Charles deKay, cited in Young, *op. cit.*, and in *Emma Lazarus* by Dan Vogel, Twayne Publishers, Boston, 1980.

[34] Richard Gilder, cited in Vogel, *op. cit.*

[35] *An Epistle to the Hebrews*, Epistle 12.

[36] Wiesel, in his autobiography, accuses Jewish communities in the free world, especially America and Palestine, of failing to act or lobby on behalf of the Jews of Europe.

[37] *An Epistle to the Hebrews*, Epistle 2.

[38] Charles Dana, editor of the *New York Sun*, cited in Young, *op. cit.*

[39] *An Epistle to the Hebrews*, Epistle 15.

[40] At the time of writing, the Emma Lazarus Fund has just been founded by the financier, George Soros, to help legal immigrants in the United States. This is to counteract the new welfare law passed by the United States Congress which will bar most legal immigrants, including permanent residents and refugees granted asylum, from receiving a number of benefits. Emma Lazarus, who believed passionately in an America of 'world-wide welcome', would surely have fought against the new ruling.

Notes to Text

(Some of the notes, where appropriate, are taken from the selections edited by Morris U. Schappes.)

[1] From *The American Hebrew*, 14, 21, and 28 November 1884. The paper was read before the Philadelphia Young Men's Hebrew Association on 12 November 1884.

[2] See *The Last National Revolt of the Jews* for the story of Bar Kochba, p. 43-4

[3] This extract was taken from *The American Hebrew*, 28 November 1884.

[4] Salvador.

[5] She points out that Reuchlin was not Jewish.

[6] 'The Jewish Problem' was published in *The Century* in February 1883. The above extract was taken from a preview excerpt published in *The American Hebrew* on 19 January 1883. Other

extracts used are taken from excerpts reprinted by Morris U. Schappes in *Emma Lazarus: Selections from her Poetry and Prose*, New York, 1944.

[7] Translated from the Hebrew of Abdul Hassan Judah Ben Ha-Levi, a poet of Mediaeval Spain, born between 1080–90.

[8] From this point to the end of the scene is a literal translation of the Hebrew burial service.

[9] Service for Day of Atonement.

[10] The vine creeps on the earth, trodden by the passer's foot, but its fruit goes upon the table of princes. Israel now has fallen in the depths, but he shall be great in the fullness of time – Talmud.

[11] Conclusion of service for Day of Atonement.

[12] Rabbi Solomon Levi of Burgos (c. 1351–1435) turned Christian in 1391, during a bloody massacre of the Jews. His wife and son renounced him. He became an instrument of Pope Benedict XIII in his schismatic rivalry with Cardinal Pedro, the Pope at Avignon. After that he held many high offices, constantly attacking Jews and Judaism. Joshua ben Joseph Ibn Vives was a physician and Arabic scholar in Lorca, and a former pupil of the apostate. In sending the poem to *The American Hebrew,* where it was published, 16 June 1882, Emma Lazarus wrote: 'It has a strong bearing on the question of the day, besides having a curious historic interest.'

[13] *By the Waters of Babylon* was the last work to be published in her lifetime, first appearing in *The Century*, March 1887.

[14] 'The Poet Heine' was published in *The Century* of December 1884. These extracts are taken from excerpts reprinted by Morris U. Schappes in *Emma Lazarus: Selections from her Poetry and Prose*, New York, 1944, and from preview extracts published in *The American Hebrew* of 21 November 1884.

[15] 'Russian Christianity versus Modern Judaism' was published in *The Century* in May 1882 in reply to 'Russian Jews and Gentiles, from a Russian Point of View' by Madame Z. Ragozin. This extract was taken from excerpts reprinted by Morris U. Schappes in *Emma Lazarus: Selections from her Poetry and Prose*, New York, 1944.

[16] *The Jews of Barnow*, by Karl Emil Franzos, translated by M.W. McDowall, with an Introduction by Barnett Philips, New York, D. Appleton & Co.

[17] These cities were the sites of some of the pogroms that started in Russia in 1879 and spread to other countries nearby.

[18] The letter was shown to Emma Lazarus by Michael Heilprin

(1823–1888), who had come to this country in 1856. In 1879–1880 he published the first two volumes of *Historical Poetry of the Ancient Hebrews*. He was very active in aiding the refugees from the pogroms.

[19] Written in aid of Bartholdi Pedestal Fund, 1883.

[20] Moses Maimonides (1135–1204), great Rabbi and scholar, author of *Mishnah;* Isaac ben Jehuda Abarbanel (1437–1508), minister of state of Alfonso V of Portugal and then chancellor to Ferdinand the Catholic, King of Castile, until driven into exile; Moses Mendelssohn (1729–86), first great champion of Jewish emancipation in the 18th century, called the Luther of German Jewry for translating parts of the Old Testament into German; Judah B. Solomon B. Hophni Alcharisi, early 13th-century Hebrew poet living in Spain; Moses Ben Jacob Ha-Sallah Ibn Ezra (*c.* 1070 – *c.* 1138), Hebrew poet, linguist, and philosopher, living in Spain.

[21] The sons of Mattathias – Jonathan, John, Eleazar, Simon (also called the Jewel), and Judas, the Prince.

[22] The Mizpeh was a place of solemn assembly for the Jews of Palestine at the time of the Maccabean revolt against Antiochus IV, 175–164 BC.

[23] See the Book of Ezra, Old Testament.

[24] The poem was first read at the closing exercises of the Temple Emanu-El Religious School, New York, and then appeared in *The Critic,* 3 June 1882, and was reprinted in *The American Hebrew,* 9 June 1882.

[27] From *The American Hebrew*, 3 November 1882 to 23 February 1883.

[28] Gabriel Charmes (1850–86), democrat and friend of Heine, author of books on Egypt, Turkey, and Naval Reform; Ernest Havet (1813–89), author of *Le Christianisme et ses origines* (1871–84); Laurence Oliphant (1829–1888), in *Land of Gilead*, 1880, proposed a Jewish colony in Palestine; George Eliot (1819–80) in *Daniel Deronda*, 1876, proposed the creation of a Jewish national land.

[29] Report of Mr Julius Schwartz on Cotopaxi Colony.

[30] This article was reprinted in *The American Hebrew* of 1 September 1882 from the *New York Sun* of the previous Sunday. In a leading article in the same edition under the title of 'A New Preacher', the editors of *The American Hebrew* comment that Miss Lazarus has found that 'Judaism does not restrict its adherents; that it places no bar to liberal thought.'

Emma Lazarus

[31] 'M. Renan and the Jews' was published in *The American Hebrew*
of 24 October 1884. This extract was taken from excerpts
reprinted by Morris U. Schappes in *Emma Lazarus: Selections
from her Poetry and Prose*, New York, 1944.

[32] Lassalle (1825–1864); Karl Marx (1818–1883), founder of
scientific socialism; Jacoby (1805–1877), Reichstag deputy from
Berlin in 1870, author of a widely translated speech, 'The Social
Question'. Marx fought Lassalle for betraying the people to
Bismarck while he respected Jacoby as a consistent democrat. On
19 November 1870 Jacoby addressed a mass meeting at Cooper
Union in New York to protest the continuation of the Franco-
Prussian War. *The Workingman's Advocate* (Chicago), 3
December 1870, states: 'An enthusiastic demonstration of
applause was given for Jacoby, the great German leader of the
political-socialists movement in Germany....'

[32] *Cain*, Act I, Scene 1.

[33] 'A Day in Surrey with William Morris' was published in *The
Century* of July 1886. This extract was taken from excerpts
reprinted by Morris U. Schappes in *Emma Lazarus: Selections
from her Poetry and Prose*, New York, 1944.

[34] From *The New York Times,* 2 October 1881.

Bibliography

Lazarus, Emma, *The Poems of Emma Lazarus*. 2 vols. Boston and New York: Houghton, Mifflin and Company, The Riverside Press, Cambridge, 1895.

Lazarus, Emma, *Songs of a Semite: The Dance to Death and Other Poems*, New York: Office of The American Hebrew, 1882.

Lazarus, Emma, *Selections from her Poetry and Prose*, ed. Schappes, Morris U. New York: Cooperative Book League, 1944.

Lazarus, Emma, *Selections from her Poetry and Prose*, ed. Schappes, Morris U. New York: Emma Lazarus Federation of Jewish Women's Clubs, 1882.

Lazarus, Emma, *An Epistle to the Hebrews*, Centennial Edition, ed. Schappes, Morris U. . New York: Jewish Historical Society of New York, 1987.

Cowan, Paul and Rachel, *Mixed Blessings*, New York: Doubleday, 1987.

Geffen, David, 'Strumming the Hebrew Lyre' in *Jerusalem Post*, 15 November 1987.

Janowitz, Anne, 'Torch Songs: the Poetry, Politics and Identity of Emma Lazarus', *Jewish Quarterly*, Spring 1996.

Raphael, Chaim, *Minyan: 10 Jewish Lives in 20 Centuries of History*, Malibu: Pangloss Press, 1992.

Vogel, Dan, *Emma Lazarus*, Boston: Twayne Publishers, 1980.

Emma Lazarus

Young, Bette Roth, *Emma Lazarus in her World: Life and Letters*, Philadelphia and Jerusalem: The Jewish Publication Society, 1995.